LIVERPOOL
MURDERS AND
MISDEMEANOURS

KEN PYE FRSA

AMBERLEY

First published 2020

Amberley Publishing
The Hill, Stroud
Gloucestershire, GL5 4EP

www.amberley-books.com

British Library Cataloguing in Publication Data.
A catalogue record for this book is available from the British Library.

ISBN 978 1 4456 9593 8 (paperback)
ISBN 978 1 4456 9594 5 (ebook)

Typesetting by Aura Technology and Software Services, India.
Printed in Great Britain.

CONTENTS

INTRODUCTION

Since its founding in 1207, Liverpool and its port have been a melting pot of people from all over the world. Millions have passed through on their way to some other part of the globe, and hundreds of thousands stayed and made the City on the Mersey their home.

Most wanted to be part of this thriving, exciting, and complex place, and sought to make a contribution to it. Sadly though, and just like anywhere else on earth, there have been those who simply wanted to satisfy their own greed or passions with no consideration or compassion for others, or for their community. Most of these simply blended in with the mass of outsiders who passed through our criminal justice system; others though, stood out for a variety of reasons.

This book has two things. First, it tells a selection of stories about some of the most curious and fascinating serious crimes in Liverpool's history, and of the people who perpetrated them. These tales are all absolutely true, no matter how bizarre or unusual they may be. Second, it tells how the authorities in the town (and the city that Liverpool became) – from monarchs and aristocrats, to judges, magistrates, and the mob – dealt with their n'er-do-wells, miscreants, and murderers over the centuries, and it does so in sometimes very grisly detail.

All things considered, I am sure you will find the stories that I have chosen for you to be an enthralling, informative, and enjoyable journey through just some of the 'Murders and Misdemeanours of Liverpool'.

IN THE BEGINNING: STOCKS, PILLORIES, AND CUCKING STOOLS

During the first 1,100 years of England's written history the country was conquered and occupied a number of times by different races of people. These were Romans, Celts, Angles, Saxons, Jutes, and Vikings. Then, in the year 1066, came the most vicious, complete, and persistent enemy of all – the Norman French.

William of Normandy (*c.* 1028–87) – 'The Conqueror' – won the crown of England at the Battle of Hastings and declared himself the rightful king. He then set about completely obliterating everything Anglo-Saxon that he could, including the language, customs, way of worship, legal system, and the very structure of English society. He replaced these with the strict cultural and political ranking structure that was the 'feudal system' and the country would never be the same again.

Life under successive Norman and Plantagenet monarchs was harsh, brutal, and seriously murderous; not least of all under King John (1167–1216). Said to have been a selfish, spoilt, sullen, and vindictive man, who was given to childish tantrums, he has passed into popular history as 'Bad King John'. Greedy, ruthless,

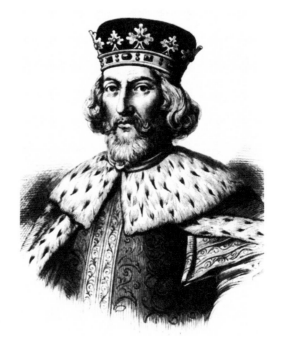

King John, the founder of Liverpool.
(Discover Liverpool Library)

and most certainly not to be trusted, John even murdered young hostages he was holding prisoner. These included his teenaged nephew, Duke Arthur of Brittany (1187–1203), whom he had kept imprisoned in a deep dungeon, until, in a drunken rage, it is believed that the king tied rocks to the sixteen-year-old young man and pushed him into a river to drown.

In 1210, King John captured the powerful English noblewoman Maud de Braose (b. *c.* 1155) and her eldest son, William (b. unknown). They were transported to Windsor Castle in cages and later moved to Corfe Castle in Dorset. Here, in the same year, John had them walled up alive in a dungeon to starve to death. In 1212, the belligerent monarch hanged twenty-eight sons of Welsh princes and lords whom he was holding hostage, including 'an excellent boy not yet seven years old'.

However, John was seldom successful in battle, earning himself the nickname of 'Softsword', which only belittled his prowess on the battlefield! When he came to the throne, in 1199, he inherited a vast empire in France but by the time of his death he had lost most of this, earning himself another nickname, as 'John Lackland'.

The people, and the aristocracy, were no longer prepared to put up with this, so the barons rebelled and, in 1215, King John was forced to sign the Magna Carta, at Runnymede in Surrey. This charter of rights laid the foundations for what would become modern British civil liberties.

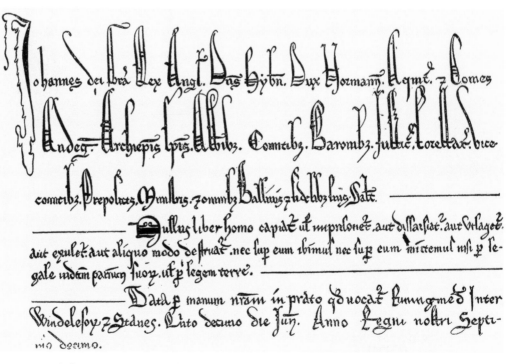

Part of the Magna Carta, which the barons forced King John to sign. (Discover Liverpool Library)

In 1207, John founded Liverpool – 'Leverpul' as it was then known. Needing a north-west harbour from which to support his invasion of Ireland, John's men had discovered what was then nothing more than a tiny fishing hamlet of just a few cottages. However, this nestled on the shore of a wide, deep, tidal inlet or 'pool' off the River Mersey. This had given the local community its name.

At high tide the pool could provide safe anchorage for the king's very large invasion fleet, so John issued 'letters patent' – or 'charter' – and so created the town and borough of Leverpul. Also, the great, 3,000-acre Toxteth Forest, which stood off the pool's southern shore, would supply all the timber needed to build his new warships. He also declared this vast area of dense woodland, with its deer, wild boar and other game, to be his own hunting reserve exclusively for himself and his courtiers.

Little did John, or those medieval 'Liverpudlians', realise that this previously unimportant hamlet would gradually develop into the most wealthy and influential city and port in the British Empire, outside London. It would hold this title for 250 years – well into the twentieth century.

But that was a long time in the future, and the newly created town of Liverpool now had to establish itself under callous rulers, self-serving aristocrats and landowners, a rigorous social structure, and living conditions so harsh that we can only imagine them.

The king ordered that seven streets be laid out in his new town, in an 'H' pattern with an extended central bar. These streets are still there, and in the same positions.

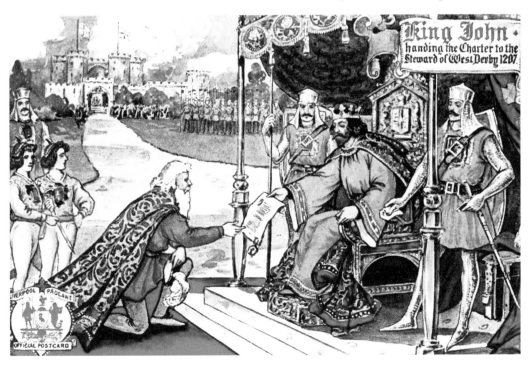

King John issuing the 'charter' that created Liverpool in 1207. (Discover Liverpool Library)

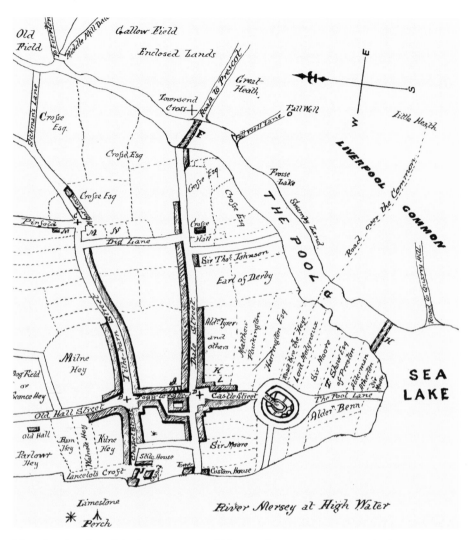

Map showing the original seven streets of Liverpool. (Discover Liverpool Library)

They are High Street (originally known as 'Juggler Street'), Old Hall Street, Chapel Street, Water Street, Tithebarn Street, Dale Street, and Castle Street. John died from dysentery in 1216, with very little mourning but, in founding Liverpool, he left an outstanding legacy.

The people of medieval Liverpool, as across the rest of Britain, needed to find diversion and amusement where they could, and these distractions reflected the cruelty and violence of the times. There were cockfights, where roosters with sharp, curved spurs fastened to their legs slashed each other to death. Then there was the spectacle of bull and bear-baiting. Here, aggressive and deliberately starved dogs were set upon the larger animals, which had been chained or

tethered to stakes or posts. This denied them escape from the inevitability of being either severely mutilated or simply torn to pieces.

Ancient attitudes to life and death did not differentiate too much between the animal and human worlds, except that when people derived entertainment from the suffering of their fellows this was mostly done in the name of 'criminal justice'. Those found guilty of crimes were put in the stocks, or were pilloried, ducked, branded, or flogged, and these public punishments always drew big crowds; in Liverpool as in every other community.

A hanging was an even better reason for a day out and a picnic, and the crowds that jeered and shouted wildly around the cock-pits and bear-pits were much larger and even more vocal when they gathered to witness these public, slow strangulations.

From 1515, Liverpool's first Town Hall stood on Dale Street near Juggler Street, and was known as the 'Exchange'. On its lower level was the town jail for locking up vagrants, drunkards, and petty criminals. However, simply locking

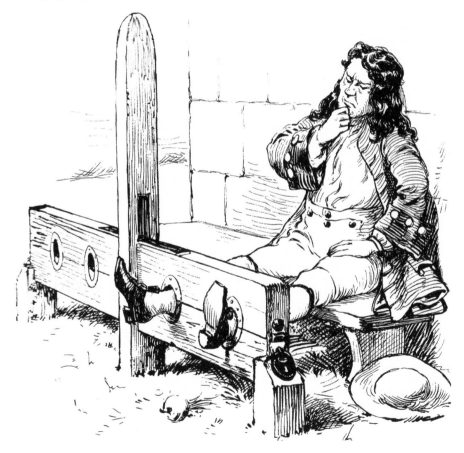

In the stocks. (Discover Liverpool Library)

someone up provided no spectacle or entertainment, nor would it be much of a deterrent to potential miscreants. Nearby, however, and offering genuine 'audience participation', stood the town stocks and the pillory, both in frequent use. In fact, by 1351, every town in England had been required by law to have and maintain a set of stocks to punish wrongdoers for a variety of crimes.

With their ankles, and often their wrists too, secured in holes through horizontal wooden boards as they sat on hard, wooden benches, people were sentenced to a period of time being locked in the stocks. For simple misdemeanours like swearing, the penalty was one hour; for drunkenness, up to six hours. Liverpool's court records of the time report that a 'naughtie person' was fined 2s 6d and sentenced to a period in the stocks for 'being sire of a bastard'. For fraud, perjury, military desertion, or other significant, non-violent offences, a person could be locked in the stocks, continuously, for several days, being fed only bread and water. They could not move even to relieve themselves. But spectators could, and frequently did, urinate or defecate on them. Everyone, except the victim, found this highly entertaining.

If the worst you suffered was abuse, spitting, kicking, humiliation, and considerable physical discomfort, then you got off quite lightly. This was because, as this punishment took place in all weathers, victims could die of hypothermia or heatstroke. It could be much worse though, if you had to spend time in the pillory. Here, and standing with your head bent forward to be secured at the neck, together with your wrists through holes in a hinged board, the townsfolk were actively encouraged to throw missiles at the victim. Sometimes these might only be mud, rotten vegetables, or manure, but they were more often sticks and stones, which did more than break bones: they could blind, permanently maim, or kill – all in the name of 'justice' and 'deterrent'. The pillory was also used for flogging, branding, having your ears cut off, or your nostrils slit. The last person to be pilloried in England was Peter James Bossy, in 1830, in London. After being found guilty of perjury his sentence was to spend one hour in the pillory. He was then transported to Australia in penal servitude for seven years.

Then there was the cruel ducking or 'cuck' stool located near the 'Watering Place', on the corner of today's Crosshall Street and Hatton Garden, off Dale Street. Standing on the edge of a deep pond, this was used to punish wives and daughters who 'misbehaved', particularly those 'whose nagging became intolerable to their men folk'! The woman was forced to sit and be tied in a chair that was secured at one end of a long, thick pole. This was mounted on a tall pivot, like a see-saw, with the chair suspended over the water. Men would use ropes attached to the other end of the pole to repeatedly raise and lower the victim into the pond, so that she was completely submerged in the often filthy and freezing water. She could be kept under water in this way for some time, frequently nearly drowning as a consequence. Indeed, death could often be the result whether intended or not.

It was a long time before such primitive punishments, and sources of public entertainment, fell into disuse. Even as late as 1799, the ducking stool was used in the House of Correction, which had by then been built on Mount Pleasant in the town. Fortunately, today we find our entertainment in ways that are less humiliating to our fellow man – or do we? *Big Brother*, *I'm a Celebrity ... Britain's Got Talent*!

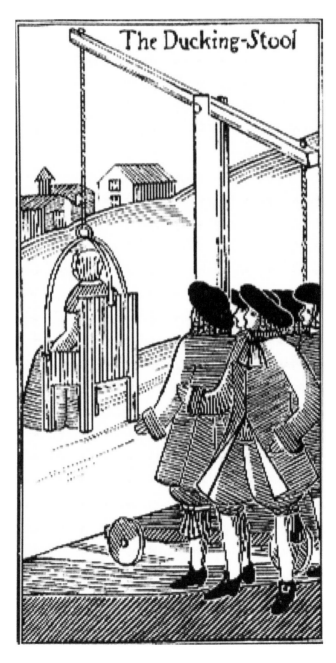

The ducking stool. (Discover Liverpool Library)

TALES OF THE CASTLE AND THE TOWER OF LIVERPOOL

Within only a few decades of its founding the town of Liverpool had two grim fortifications. These glowered down over the people and the River Mersey and its Pool. The first of these was the very large Liverpool Castle. The construction of the town's great stronghold had begun before the death of King John in 1216. The work was completed sometime between 1232 and 1237, by the then Lord of the Manor and Sheriff of Lancaster, William de Ferrers (1168–1247). This fortress was to stand for around 500 years.

The castle was an impressive stone structure, erected on what was then the highest point between the River Mersey and the original tidal 'Pool' of Liverpool. This afforded excellent views, not just of the surrounding land but also of the river, and so it was in a particularly strategic position. The castle was built out of massive sandstone blocks, and was surrounded by a moat, hewn out of the solid rock.

The building was designed to be self-sufficient in times of siege; consequently, the castle had its own bakehouse, brewhouse, and well. There was also an apple

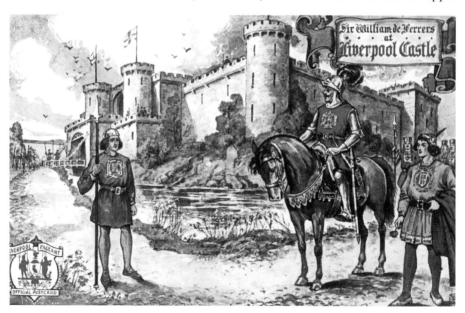

Commemorative postcard showing Liverpool Castle and its builder, William de Ferrers. (Discover Liverpool Library)

orchard on the west side of the castle, overlooking the river, and a stone-built dovecot to the south.

The building was rectangular in design, with tall, broad, circular towers at three of its corners, and a large gatehouse, barbican, and portcullis at its fourth. Another tower was added in 1441. The entrance was also guarded by a drawbridge and portcullis mounted on a causeway across the broad, deep moat. The towers and barbican were connected by high curtain walls topped by battlements, and these strong defences enclosed a broad courtyard.

Liverpool Castle also had deep cellars and, in all likelihood, dark, damp dungeons. The purpose of a dungeon was for temporarily holding prisoners or, in extreme cases, for torturing them. English history is awash with tales of the Rack, used to stretch and dislocate a victim's limbs; the Wheel, used to turn a victim whilst his (or her) limbs were broken; the Scavenger's Daughter, used to compress a victim so that their bones and sometimes their backs would break; the metal Boots, which completely encased a victims feet whilst cold water was poured into one and molten lead into the other; and the Thumbscrews, which are self-explanatory! Whilst there is no recorded evidence that Liverpool Castle was ever used for such purposes, it is most unlikely that it was not.

In the early 1980s, as Derby Square was being excavated for new law courts, the dried and perfectly preserved corpse of a Roundhead soldier was found, complete with uniform, in what appears to have been a deep cell or dungeon. Had he been locked up and left to starve to death? We are unlikely ever to know.

For centuries the castle had dominated the small town of Liverpool, its great towers and imposing gateway reminding the townspeople of where exactly lay the true power in the land. It was certainly not with them, but in the hands of the

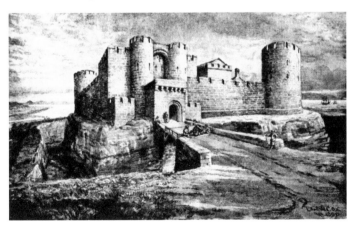

Above: Liverpool Castle. (Discover Liverpool Library)

Right: Dungeons. (Discover Liverpool Library)

aristocracy – mostly descendants of the Norman invaders of 1066. The De Ferrers family, their servants, and their soldiers had occupied the castle until 1266, when it was taken over by other nobles. By 1347, the castle's facilities had developed and there was now a large hall as well as a chapel in the main courtyard. The hall was big enough to be a dining space for all the occupants, and this also provided full stabling for the horses and other livestock – people and animals tended to occupy the same space in those days, so you can imagine the smell!

In 1440, a member of one of the town's two great aristocratic families, Sir Richard Molyneux (1396–1459), was made Constable of Liverpool Castle. This title became hereditary five years later and the Molyneuxs held the castle until the English Civil War (1642–51). During that dreadful conflict between the king and parliament Liverpool Castle was severely damaged in the last of three sieges on the town. Its ruins were completely cleared away in 1726. The Molyneuxs went on to become the Earls of Sefton and the founders of the Grand National Steeplechase.

Nothing now remains above ground to say that a castle ever stood there except a plaque noting the fact. This is mounted on the side of the large memorial statue of Queen Victoria that now stands at the centre of the site of the ancient bastion. The Old Queen has been gazing sternly down Lord Street – named after Lord Molyneux – since 1902. However, the tale of The Tower of Liverpool is much darker.

From around 1250, on the corner of what became Water Street and The Strand – literally on the waterfront of the Mersey – there stood a very large mansion house. This had been built of great red-sandstone blocks, by whom we don't know. By the beginning of the fifteenth century, it had passed into the ownership of the Stanley family. They were the second of the town's aristocratic dynasties and went on to become the Earls of Derby and the founders of the Oaks and Derby horseraces. In 1406, Sir John Stanley (1386–1432) had been granted the Lordship of the Isle of Man by King Henry IV (1367–1413). To match his new status he needed his own stronghold to demonstrate his new power and authority to the people and to his great rivals, the Molyneux family. He received permission from King Henry to transform his riverside mansion into a fortified military stronghold, large enough to garrison with his own troops. He added battlements; strong walls; turrets; a fortified gateway; two, large, central courtyards; and deep dungeons and cellars. Sir John named his new fortress 'The Tower', and it was a far grimmer place than the castle.

Of course, the Stanley family resided at the Tower when they were in the town, so on its upper levels, the building also comprised state bedrooms and a banqueting hall, as well as all the other facilities required by wealthy aristocrats.

In common with other places around Britain, and from the time that people began to settle in organised communities, Liverpool and the other towns and villages of what is now Merseyside needed to incarcerate their local wrongdoers for short or lengthy periods, depending on their crimes. For drunkards, vagabonds, n'er-do-wells, and petty miscreants, the local 'bridewell' or 'lock-up' would often serve the purpose. These were often no more than small, single-roomed, detached, secure buildings designed to hold no more than one or two people. Most of the

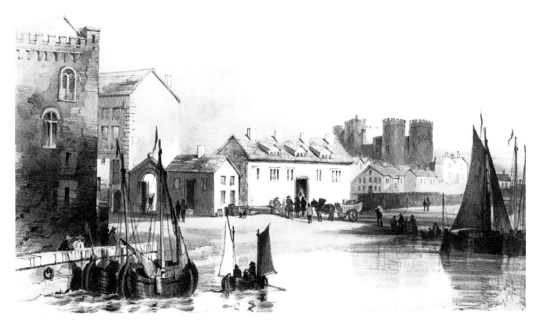

Above: On the left we see part of the Tower of Liverpool, standing at the bottom of Water Street. The castle can be seen in the background. (Discover Liverpool Library)

Right: Liverpool Tower, showing a 'fishing line' extending out into the street in the hope of charitable gifts from the public. (Discover Liverpool Library)

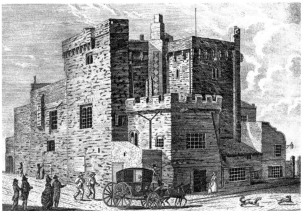

villages and communities that originally surrounded the tiny town, but which are now the suburbs of Liverpool – its 'lost villages' – each had their own such jail, but only those in Everton and Wavertree survive. These had both been built in the eighteenth century, specifically to briefly imprison people who had come to these delightful and picturesque communities as tourists, but who had enjoyed far too much of the local ales and had then made nuisances of themselves.

Also from the eighteenth century, Liverpool town itself had small bridewells near the docks to accommodate troublemaking seafarers and dockworkers. However, as the town and its population numbers expanded, these small prisons were inadequate to meet the need to accommodate equally expanding numbers of criminals – and debtors. The town now needed a larger prison.

Always a place of dread, by 1737 Liverpool Corporation was leasing the old Tower of Liverpool, and the upstairs rooms were converted for use as assembly rooms for dancing, cards, and other entertainments. However, the cellars and dungeons now became the town gaol. There were seven cells, each around 6 feet square and all well below ground level. At least three prisoners could be confined in each of these and the only light and air came in through a tiny grill above each cell door. There was no water supply or sanitation, so sickness and death were common from what was called 'jail fever', but which was actually typhus.

The human waste and filth that accumulated in the cells and dungeons could often be ankle-deep, and was only removed (by the prisoners under close guard) when the happy revellers in the assembly rooms above could no longer stand the stench. This became especially bad in hot weather. Even then, it would only be taken into the centre of one of the two courtyards, where it was piled up in a huge midden that was only removed once a month. These sewage-covered yards were also the only places where the prisoners could get any exercise.

There was a larger cell in the Tower, on the ground floor. This was big enough to accommodate ten to twelve people, but at one point it was home to over forty men, women, and children. This did have a high window, which faced out onto the street. Hoping for the charity and generosity of the public, the prisoners lowered gloves or bags, tied to strings suspended from sticks, out into the street so that kindly passers-by would drop in coins or food. Sadly, it was a favourite sport of the local boys to deposit stones, mud, or other nasty substances into the begging-bags – life was harsh and callous in those distant days.

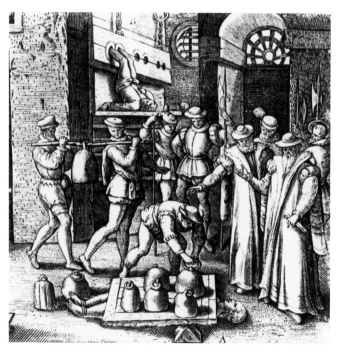

Pressing to death. (Discover Liverpool Library)

The old prison became the backdrop for public executions in front of its walls whilst other punishments took place inside. These included flogging, branding, and a particularly nasty form of penalty – 'pressing to death' under stones laid on a board on top of the condemned person.

Conditions continued to be foul beyond belief for the unfortunate people who found themselves imprisoned there. Men, women, boys, and girls were all herded together with no discrimination, and in often violent, gross, and indecent circumstances; sexual and physical abuse of both sexes was rife. Stronger prisoners bullied the weak whilst the jailers bullied everyone and extorted money from the prisoners. Cruelty, brutality, squalor, and starvation were facts of life in the Tower dungeons. In fact, what food was provided was of appalling quality and far from regular, which meant that starving prisoners were often reduced to catching and eating rats, mice, and cockroaches to survive.

But the days of the Tower were numbered and its physical condition was deteriorating rapidly, so much so that money was not available to safely maintain its structure. The Corporation of Liverpool just ignored the problem until, towards the end of the century, the town received a distinguished and angry visitor – as shall be seen in the final chapter of this book.

Modern Tower Buildings standing on the site of the old Tower of Liverpool. (Discover Liverpool Library)

'STAND AND DELIVER!'

Travel, even between local areas, is quite a modern concept. People first began to move around the country in significant numbers from the time of the Industrial Revolution (*c.* 1760–*c.* 1830), and this only became commonplace as the twentieth century dawned and 'public transportation' developed.

In the years before the English Civil War few ordinary people travelled beyond their own town or village, unless they were on 'official' business for the state or the Lord of the Manor. Merchants travelled around too, as did people going to market or a fair. However, most people lived, worked, and died in the place where they had been born, and never left it. In fact, until the mid-eighteenth century, there were only a few roads connecting Britain's communities, which were mostly self-sufficient.

When people needed to travel they did so on foot, unless they were wealthy enough to afford horses, carts, or wagons. In and around Liverpool, especially to the east, all travellers had to cross 'The Great Waste'. This was a vast area of open heath, grass, and scrubland covering the area for miles around. Narrow, winding tracks crossed 'The Waste', leading to the nearest villages, such as Childwall, Wavertree, Woolton, or West Derby.

Travellers made their journeys during the day, because that was the only time they could actually see where they were going, and because it was safer – well, up to a point! Even though these were distances of only a few miles, people were vulnerable to attacks by 'footpads', who acted alone or in small groups.

Victorian footpads
attack an isolated
traveller.

These were vicious thugs who would suddenly leap out from behind hillocks, large rocks, or occasional copses or woodlands, terrifying isolated travellers.

Footpads were ruthless, and demanded goods, money, and even the clothing of their victims. Failure to hand everything over quickly would certainly result in the robber using his 'hanger' (short sword), or a great bludgeon, or perhaps his heavy, weighted cosh, to beat, maim, mutilate, or kill. Indeed, the footpad and his gang would probably kill you anyway, leaving your naked corpse lying forlornly on the open heath.

But these villains did not always have it their own way. Sometimes the traveller would give as good, or better, than was being handed out. Sometimes too, the law would catch up with the robbers, when they would then face the ultimate penalty for their crimes – the slow, strangled hanging at the end of a noose, in front of baying crowds at their public execution.

By the closing decades of the 1600s, and before the development of canals, Liverpool was growing into an important mercantile centre. More and more goods and supplies were being transported in and around the town by road. It was cheaper, and marginally safer, to move goods this way, rather than by sea, although roads were no more than beaten footpaths, packhorse trails, or cart tracks worn into place by centuries of use.

But travel could also be hazardous because even the main routes were seldom maintained, even though local parishes were legally obliged to do so. This meant that the roads became overgrown, strewn with rocks, rutted and uneven, or full of hollows and potholes. Many of these could be quite deep and in bad weather might fill with rainwater. Many travellers fell into such holes and drowned. Often too, roads were washed away in storms or rendered completely impassable.

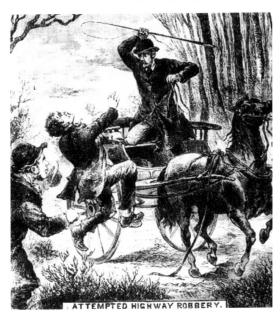

ATTEMPTED HIGHWAY ROBBERY.

Nineteenth-century highway robbers attacking on the King's Highway. (Discover Liverpool Library)

But, as travel became increasingly frequent and necessary, especially by the mid-1700s, most male travellers journeyed on horseback either alone or in small groups. Families travelled by cart, carriage, or coach, if they could afford them, and women never travelled alone because this was considered indecent. Also, the mails were being transported around the countryside and mail coaches and post-boys were now targets for robbers. These newer, faster forms of travel meant that the footpad was soon replaced by a much more sophisticated breed of roadway thief – the highwayman.

Stories paint romantic portraits of these robbers and their nefarious activities, with Dick Turpin being the most famous. In reality though, there was nothing glamorous about them at all. On the loneliest stretches of road they would ride up to block the passage of a coach and, brandishing a pistol – sometimes one in each hand – they shouted at the coachman to 'Halt, or I shall surely shoot!'

'Stand and Deliver!'. (Liverpool Athenaeum Library)

In fear for his life, the coachman would reign in the horses and bring the carriage to a stop. The highwayman might then fire a warning or a wounding shot. Next, he might actually demand 'Stand and deliver! Your money or your life!' At that time this phrase was in common use amongst such thieves on England's coaching roads.

With a distinct advantage over the footpad, that of being able to attack from a safe distance, the robber forced driver and passengers to hand over jewellery, money, silk handkerchiefs, and any 'new-fangled' pocket watches. Once these were in the thief's possession he used his other advantage over the footpad, that of being able to make a fast getaway on horseback. But, as with the footpads, highwaymen did not have it all their own way.

As highway robberies became more prevalent on roads in and out of Liverpool, travellers began to carry their own pistols and swords, and soon coaches often had armed escorts. Before long, highwaymen too found themselves captured and locked up in small, purpose-built local gaols or bridewells. One such was in Old Swan village just to the east of Liverpool and in the heart of the 'Great Waste'. Here there was a tavern and stables at the junction of four principal roads.

The Old Swan bridewell, which once stood at what is now the corner of Derby Lane and Prescot Road, was not well constructed. The large blocks of sandstone that made up its walls were not very well mortared, leaving narrow gaps between them. The roof and the iron door may have been secure, but the friends and associates of the captives frequently pushed the long stems of clay 'churchwarden' pipes through the cracks.

A highwayman making his escape on horseback. (Discover Liverpool Library)

A clay churchwarden-style pipe ready to be converted into a straw! (Discover Liverpool Library)

Breaking off the bowls of these pipes, they then placed the outside ends of the stems into tankards of wine or ale. With the inside end between his lips the prisoner could then suck up as much drink as his friends could supply. This meant that a highwayman might be locked up completely sober yet be unlocked and taken to be hanged in a state of advanced drunkenness – perhaps this made his protracted throttling less of an ordeal because hanging was not a quick death in those days.

The highwayman began to vanish from British roads by the early years of the nineteenth century; in fact, the last recorded robbery by a mounted highwayman took place in 1831. It was the development of better-maintained, wider, turn-piked stagecoach roads, with manned toll-houses every few miles that eventually saw off these robbers on horseback. Now it was almost impossible for a highwayman to make a getaway without witnesses, or without lots of people to chase him to ground.

All we have now, in popular mythology, are tales of glamorous, masked, cloaked, 'gentlemen thieves of the road' when, actually, these were dangerous, unscrupulous, violent thugs and murderers.

Incidentally, the word 'turnpike' was originally the name given to a gate-like frame, pivoting at one end on an upright post or 'pike', and these had been originally used on tracks to block the passage of cattle and other animals. Such gates were now used on the coaching roads, blocking the way every few miles so that tolls could be collected to pay for the maintenance of the 'King's Highway'. Eventually, 'turnpike' became the term for the roads themselves.

GRUESOME RETRIBUTION

For my next tale I am moving forward in time to the eighteenth century, and I shall begin this story with a road. This was, and remains, a main thoroughfare in and out of Liverpool, and it runs to the east of the modern city. This road was named 'London Road' because if you travelled far enough along it, that is where it would eventually take you.

For many years the only buildings in London Road were some windmills and an isolated inn, known as the 'Gallows Mill Tavern'. Standing close to the road's junction with what is now Stafford Street was the site of a special gallows and scaffold. This had been built to fulfil a particularly gruesome function following the Jacobite Rebellions. These major military uprisings had their roots in the English Civil War and the animosity between Catholics and Protestants.

In 1685, King Charles II (b. 1630) died, but not before converting to Catholicism on his deathbed. Having no legitimate heir, although he had plenty of illegitimate children, the throne passed to his brother who became King James II (1633–1701). Charles and James were descendants of the Scottish Stuart line of kings who then ruled England, Scotland, Ireland, and Wales.

In 1669, King James had also converted to Catholicism, but this did not prevent his succession, although many in England were concerned by his faith, and by his attempts to install fellow Catholics in influential positions. One such rebel was Charles II's illegitimate son, the Duke of Monmouth (1649–85), who was a Protestant. He raised an army and marched from Scotland against the king.

The Gallows Mill Tavern, which was the site of the multiple execution of Jacobite rebels. (Discover Liverpool Library)

This was speedily quashed, and Monmouth was executed. Unfortunately though, the life of Monmouth was not likewise 'speedily quashed'.

On 15 July 1685, the Duke of Monmouth was to be beheaded on Tower Hill in London by the notorious executioner Jack Ketch (d. 1686), who had a reputation for botching his executioner's duties. But, before laying his head on the block, the duke told the famously incompetent axeman to make sure that he took his head off with one blow.

The request unnerved Ketch who, as a result, took between five and eight attempts to complete the decapitation, with the tragic duke screaming for mercy throughout the debacle. A report from the time stated that 'the prisoner rising up reproachfully the while a ghastly sight that shocked the witnesses, drawing forth execrations and groans. Some say a knife was at last employed to sever the head from the twitching body'.

An apocryphal tale went the rounds that, after the execution, it was realised that no portrait of the duke had ever been painted, so his head was sewn back on again to allow an artist to do so.

In 1688, James II had a son, James Francis Edward (d. 1766), which convinced Protestant nobles in the kingdom that a Catholic succession was about to be imposed on them. They invited the Protestant Prince William of Orange (1650–1702), from the Netherlands, to take the throne. In what became known as 'the Glorious Revolution', William landed in Devon with a large army,

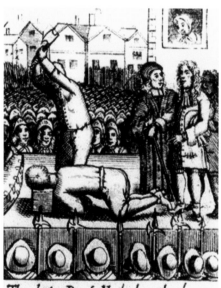

The late D of M beheaded on Tower Hill 15 july 1685

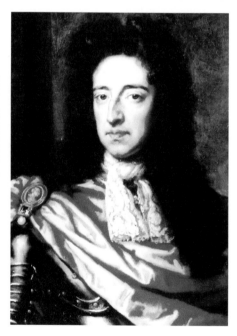

Above left: The tragically botched execution of the Duke of Monmouth.

Above right: King William III of Orange. (Liverpool Athenaeum Library)

whilst King James had assembled a force of troops to defend his crown. However, James's army and navy deserted him, forcing him to flee abroad. William of Orange, with his wife, Mary (1662–94), were crowned joint monarchs that same year.

William and Mary were subsequently succeeded by the Protestant Hanoverian Kings George I (1660–27) and then by George II (1683–1760). However, both these monarchs had to deal with rebellions from members of the exiled Stuart dynasty, each determined to reclaim the British thrones and rule as Catholics.

The most significant of these uprisings were known as 'the Jacobite Rebellions', taking their name from 'Jacobus', the Latin form of James. The 'First Jacobite Rebellion' took place in 1715, so became known as 'The Fifteen'. This was led by the son of King James II, James Francis Edward Stuart, who later became known as 'the Old Pretender'.

Coming to Scotland from his place of exile in France, James soon found his rebellion collapsing almost as soon as it had started, despite some ferocious fighting between rebel and government troops. The Jacobites suffered major defeats at the battles of Preston and Sheriffmuir, and many rebels were slaughtered. James abandoned his lost cause, leaving England for France again, never to return. A number of rebels were executed, others were deported, peerages were forfeited, and Scottish clans were disarmed.

The 'Second Jacobite Rebellion' took place in 1745, so became known as 'The Forty-Five'. This was led by the son of the Old Pretender, Charles Edward Stuart (the Young Pretender, 1720–88). He is better known to history

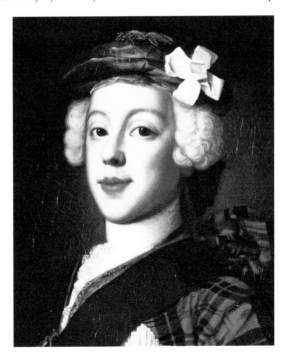

Bonnie Prince Charlie.
(Liverpool Athenaeum Library)

as 'Bonnie Prince Charlie'. The twenty-five-year-old was to have much greater success in his uprising than his father had experienced, but only up to a point.

Sailing to Scotland from France, which was also his place of exile, Charles raised the Jacobite standard at Glenfinnan in the Scottish Highlands where he was supported by a gathering of Highland clansmen. They first marched towards Edinburgh where they were victorious at the Battle of Prestonpans. Confident of further victories, they crossed the border into England.

Making their way to Carlisle, the Jacobites then continued deeper into the North West, heading towards Liverpool. Panic spread before them, except in the town, which was staunchly Georgian and Protestant, and the people here were ready to repel the rebels and defend themselves. A volunteer force of over 2,000 men mustered from the town were funded by the Liverpool Corporation and a public subscription. These were called the 'Liverpool Blues'.

Perhaps because of the town's preparedness Bonnie Prince Charlie carefully avoided Liverpool and instead continued his march as far as Derby. Still wanting to play their part, the 'Blues' marched to support the army of King George and fought victoriously against the Young Pretender. The rebel leader and the remnants of his troops were driven all the way back to Scotland again, retreating to Inverness.

In acknowledgment of their loyalty and courage, the Liverpool Blues received the honour of a Royal Inspection by their commander, Prince William Augustus, Duke of Cumberland (1721–65), the son of King George II. To acknowledge and reciprocate this honour, the town of Liverpool laid out new streets and named them after the duke: Hanover, Duke, and Cumberland Streets, which remain some of the modern city's busiest roads.

It was near Inverness that the final battle of the Jacobite Rebellion was fought, and it was also the last battle ever fought on British soil, at the moor known as Culloden. Bonnie Prince Charlie led an army made up of a number of Scottish clans that were attacked by the Duke of Cumberland who was leading the king's troops. The Duke won the battle but offered little mercy to the rebels, becoming known ever afterwards as 'The Butcher of Culloden'. The Young Pretender had fled the battlefield and spent the summer of 1746 wandering around the Highlands of Scotland. He soon returned to France, and permanent exile, where he died.

After the first Jacobite Rebellion had finally been put down, captured Jacobites had been held prisoner in the ancient gaols of Lancaster, Preston, Chester, and in the unwholesome dungeons of the Tower of Liverpool.

Between 20 January and 9 February 1716, a specially convened court was held in Liverpool to try seventy-four Jacobites for high treason; sixty of them were found guilty. Of those men who had admitted their offence a number avoided the death penalty. Some were transported to penal colonies in Australia whilst others were imprisoned in Britain. Even so, their prison conditions were so harsh that many of them died anyway, of disease or malnutrition. Thirty-four men were

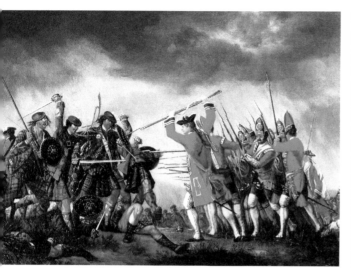

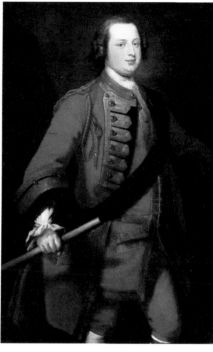

Above: The Battle of Culloden. (Discover Liverpool Library)

Right: The Duke of Cumberland, the 'Butcher of Culloden'. (Discover Liverpool Library)

sentenced to be executed, in various towns around the north-west of England, as an example and a deterrent: And what a grisly end it was to be too – the traitors' death by 'hanging, drawing, and quartering'.

This evil and sadistic form of execution was invented in 1241, specifically to punish a man called William Maurice who had been convicted of piracy. In 1283, Dafydd ap Gruffydd, the last native Welsh Prince of Wales (born *c.* 1235) also died this way, as did William Wallace (*c.* 1270–1305) 'Braveheart', at Smithfield in London. Guy Fawkes (b. 1570) and his fellow 'Gunpowder Plot' conspirators had also been victims of this terrible punishment, in 1606, but now it was the turn of the Jacobite rebels.

On 15 February 1716, four terrified prisoners, whom records name as 'a Mr. Burnett, Alexander Drummond, George Collingwood, and John Hunter', were dragged from the dungeons of the Tower of Liverpool, where they had been held. They were tied to a type of sled and horses pulled this through the streets of the town to its outskirts. Here, near three windmills, a specially constructed scaffold platform with gallows had been erected.

Then, in front of a very large crowd, the condemned men faced their executioners. This complex penalty required a number of such professionals to carry it out, who were paid £10 and 3 shillings for their work. With the last of the prisoners forced to witness the other three die before him, in turn, the gruesome process began.

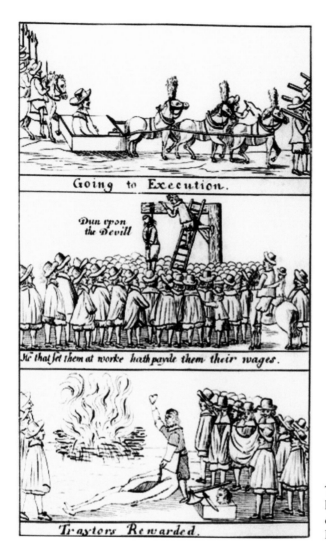

The grisly process of hanging, drawing, and quartering. (Discover Liverpool Library)

First, the victim was stripped naked and hanged by the neck from the gallows, slowly strangling. Then, and just before death, he was taken down, still living, stretched spread-eagled on the scaffold platform, and tied down by his wrists and ankles. His genitals were then hacked off and burned in a fire in front of his eyes. Next, his belly was slit open and his intestines were slowly pulled out of him, or 'drawn'. These too were then burned before his eyes.

Only when this process was complete would the screaming man, awash with his own blood, be put out of his anguish by having his head slowly sawn off. His mutilated body was then cut into four quarters, each one to be displayed on a pike in a different town in the region, again as an example and deterrent.

Women traitors were much more fortunate though. To preserve public decency they were only slowly roasted alive as they burned at the stake!

THE PRIME MINISTER'S ASSASSIN

Of all the many murders that have been committed in Liverpool, or by Liverpudlians, one stands out as being driven by both passion and politics, and by a great personal injustice.

Arguably, Britain's most unremarkable prime minister was Spencer Perceval MP (1762–1812); he is notable simply because he was the only British premier to have been assassinated. His murderer was John Bellingham (*c.* 1771–1812), a shipping merchant and insurance broker from Duke Street in Liverpool, who was married with two children.

In 1804, whilst on a business trip to the Arctic Russian port of Archangel, Bellingham was accused of being in debt for the sum of 2,000 roubles, which the broker denied and so refused to pay. He was arrested and, although still vehemently denying his guilt, he was sentenced to five years in prison. It was small consolation to Bellingham that he was treated reasonably well and allowed to move freely about the prison, but he knew he should not be there.

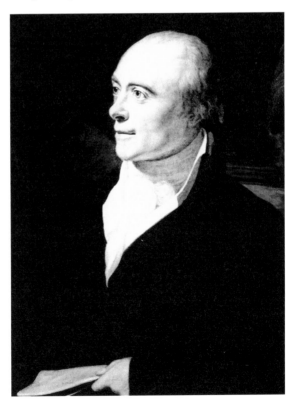

Spencer Perceval MP, Britain's only assassinated prime minister. (Discover Liverpool Library)

He had appealed directly to the English consul for assistance and also to the British ambassador at St Petersburg. They both refused to get involved. Serving his full sentence, Bellingham was eventually released in 1809, and he returned to Liverpool. He immediately tried to get compensation from the British government for his mistreatment. He firmly believed that, because their representatives had completely failed to come to his aid, they were ultimately responsible for his long and unjustified incarceration. However, once again, officialdom would not entertain his case. For the next three years Bellingham persisted, petitioning first the Privy Council and then the Treasury, just as fruitlessly.

Bellingham next requested that his local MP from Liverpool, General Isaac Gascoigne (*c.* 1763–1841), formally petition parliament on his behalf. Bellingham wrote to his MP a number of times, but Gascoigne, also known as 'Cunning Isaac', and generally recognised as being an a incompetent and entirely self-serving individual, refused absolutely. He declared that his constituent's case had no merit and most certainly did not deserve his attention. Gascoigne was far too busy vigorously campaigning to retain the slave trade, fighting against the abolition of bull-baiting, and opposing the emancipation of Roman Catholics!

Bellingham also wrote to the Prince Regent, later King George IV (1762–1830), and received yet another rejection. The thwarted but relentless man then wrote directly to the prime minister. When Perceval also refused to become involved the Liverpool businessman became increasingly resentful and bitter.

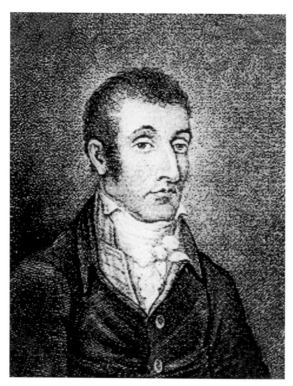

John Bellingham, the Liverpool merchant with a major grievance. (Discover Liverpool Library)

So, on 23 March 1812, Bellingham's final and quite unusual course of action was to write to the police magistrates in London:

SIRS,

I much regret its being my lot to have to apply to your worships under most peculiar and novel circumstances. For the particulars of the case I refer to the enclosed letter of Mr Secretary Ryder, the notification from Mr Perceval, and my petition to Parliament, together with the printed papers herewith.

The affair requires no further remark than that I consider his Majesty's Government to have completely endeavoured to close the door of justice, in declining to have, or even to permit, my grievances to be brought before Parliament for redress, which privilege is the birthright of every individual.

The purport of the present is, therefore, once more to solicit his Majesty's Ministers, through your medium, to let what is right and proper be done in my instance, which is all I require.

Should this reasonable request be finally denied, I shall then feel justified in executing justice myself – in which case I shall be ready to argue the merits of so reluctant a measure with his Majesty's Attorney-General, wherever and whenever I may be called upon so to do.

In the hopes of averting so abhorrent but compulsive an alternative I have the honour to be, sirs, your very humble and obedient servant,

JOHN BELLINGHAM.

This implied threat of physical violence against an unnamed target was passed to the British treasury. In response, a Mr Hill asked Bellingham to come and see him. Expecting, at last, to now be taken seriously, Bellingham travelled to London. However, the now optimistic merchant was appalled when Hill informed him that he still had no legitimate grievance, and insisted that he stop his hectoring of the government, its departments, and its ministers. Bellingham was now outraged and a court report at the time states that,

This (Bellingham) declared he considered a carte blanche to take justice into his own hands, and he accordingly determined to take such measures of revenge as he madly supposed would effectually secure that attention and consideration for his case which he deemed it had not received, and to which it was in his opinion fully entitled.

This was when John Bellingham decided to 'punish' the prime minister, the person he felt bore the ultimate responsibility for his suffering.

Monday 11 May 1812 was a sunny day. It was early evening when Prime Minister Perceval entered the House of Commons and made his way through the lobby towards the chamber. Bellingham had been sitting quietly and unobtrusively in a corner of the lobby, making no attempt to either conceal or draw attention to himself.

As the prime minister began to walk past him the vengeful Liverpudlian stood and took a pistol from a special pocket he had made inside his overcoat. Bellingham then pointed the weapon at the unsuspecting politician and fired a single shot at point-blank range.

The pistol ball struck Perceval in the chest and he immediately cried out, 'I am murdered!' He then staggered and fell to the floor. Still alive but mortally wounded, Perceval was carried to the Speaker's apartments by a number of men. Meanwhile, his attacker simply walked back to his corner and sat down again.

A doctor was summoned whilst the ashen prime minister was placed on a table. He said nothing more, but uttered one or two pain-racked sobs. However, some reports have the dying man clambering up off the table, reeling a short distance, and then crying out before collapsing in delirium, 'I'll have one of Belamey's veal pies!'

By the time the doctor arrived Spencer Perceval was dead. He was forty-nine years old and left a very devoted wife and twelve children.

Meanwhile, back in the lobby, someone shouted, 'Shut the door! Let no one out!', and then another voice cried out, 'Where's the murderer?' Bellingham, who was still holding the pistol, answered, 'I am the unfortunate man!' He was immediately seized, ironically by General Gascoigne, the very Liverpool MP who had failed to help him, and who immediately took possession of the pistol. Bellingham said nothing else, but reports describe him as sweating heavily and finding great difficulty in breathing.

When searched, Bellingham was found to have another primed and loaded pistol inside his coat, so this was also carefully removed. The Speaker of the

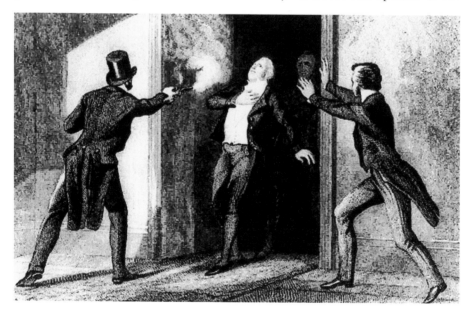

Bellingham shoots the prime minister at point-blank range. (Discover Liverpool Library)

House now ordered that Bellingham be taken to the Sergeant-at-Arms' quarters for questioning. Throughout, the assassin remained calm and collected, and offered no resistance. In fact, he immediately admitted to the murder, and said, 'I have been denied the redress of my grievances by Government. I have been ill-treated. They all know who I am and what I am. I am a most unfortunate man and feel here sufficient justification for what I have done.'

By this time, news of the prime minister's shooting had reached beyond the walls of the parliament building. The authorities now feared that there might be outbreaks of violent support for the killer, and possible attempts at his rescue. This was a time when revolution was rife across the continent of Europe, so these fears were not out of place. Nor were they unfounded – the government of the day was deeply unpopular, and the gap between ordinary people and the rich and powerful was very wide indeed.

When a coach arrived at around 8.00 p.m. to take Bellingham to prison, a mob had indeed gathered outside. Some of them surged towards the prisoner in an attempt to help him escape, and they had to be forced back. Bellingham was taken back inside the parliament building again until a contingent of troops arrived at around midnight. Soon after 1.00 a.m., and with much of the angry mob now dispersed, these armed soldiers escorted the coach, with Bellingham aboard,

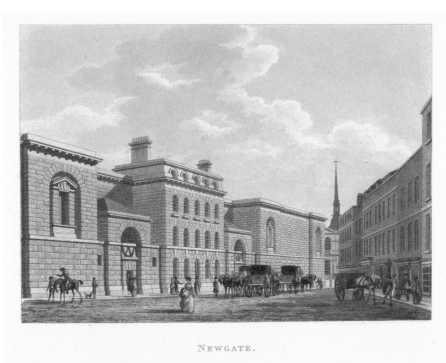

NEWGATE.

Newgate Prison. (Yale Center for British Art)

to Newgate Gaol. Here, he was chained and secured in a cell, but he simply lay down and almost immediately fell asleep.

On the advice of his defense council, John Bellingham pleaded 'not guilty' to the charge of murder, but he was certainly resigned to his fate, which in those days was inevitable. The tragic Liverpool businessman was tried in a very overcrowded courtroom at the Old Bailey on Friday 15 May, and the trial report states:

> At length Bellingham appeared, and advanced to the bar with a firm step, and quite undismayed. He bowed to the Court most respectfully, and even gracefully; and it is impossible to describe the impression which his appearance, accompanied by this unexpected fortitude, produced. He was dressed in a light brown surtout coat and striped yellow waistcoat; his hair plainly dressed, and without powder.

During the hearing, which lasted for only a day, a journalist reported that he remembered previously seeing Bellingham, on a number of occasions, in the visitors' gallery of the House of Commons. He had been noted repeatedly asking people to point out significant MPs and Cabinet Members to him, including the prime minister. As far as the court was concerned this showed that he had planned his attack and so proved intent. This also meant that when his lawyer mounted a plea of insanity this was ruled out by the court.

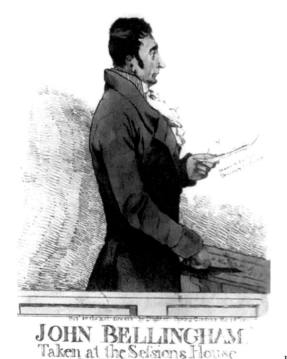

JOHN BELLINGHAM
Taken at the Sessions House
Old Bailey, May 15 1812.

John Bellingham gives testimony in court. (Discover Liverpool Library)

In his testimony, Bellingham firmly declared that he had no personal animosity towards Perceval, and he seemed to show genuine remorse for the prime minister's death, and for the fate of the politician's family. He declared that the only motive for the shooting had been 'want of redress and denial of justice'.

Inevitably, Bellingham was found guilty and sentenced to be hanged, and that his body be 'dissected and anatomised'.

However, on the eve of his execution, John Bellingham received a message that two gentlemen from Liverpool had called at Newgate, with assurances that he was to have no concern because they would ensure that his wife and children would be well taken care of and would want for nothing.

Sympathy for his case, and for his attempts to thwart government, was widespread in Liverpool, and a subscription had already been taken up in the town to raise a fund for his family. When Bellingham received this news in his cell he asked for a pen and paper and wrote home to his wife:

MY BLESSED MARY, –

It rejoiced me beyond measure to hear you are likely to be well provided for. I am sure the public at large will participate in, and mitigate, your sorrows; I assure you, my love, my sincerest endeavours have ever been directed to your welfare. As we shall not meet any more in this world, I sincerely hope we shall do so in the world to come.

My blessing to the boys, with kind remembrance to Miss Stephens, for whom I have the greatest regard, in consequence of her uniform affection for them. With the purest intentions, it has always been my misfortune to be thwarted, misrepresented and ill-used in life; but however, we feel a happy prospect of compensation in a speedy translation to life eternal.

It's not possible to be more calm or placid than I feel, and nine hours more will waft me to those happy shores where bliss is without alloy.

Yours ever affectionate,
JOHN BELLINGHAM.

On 18 May, John Bellingham was taken to the scaffold at Tyburn in a cart, which was followed by a large crowd of people who shouted, 'God bless you!', and other words of encouragement to him. A report of his execution said,

He ascended the scaffold with rather a light step, a cheerful countenance, and a confident, calm, but not an exulting air. He looked about him a little, lightly and rapidly, which seems to have been his usual manner and gesture, but made no remark.

John Bellingham died with resignation and dignity two days after the funeral of the murdered prime minster had been held. René Martin Pillet, a Frenchman

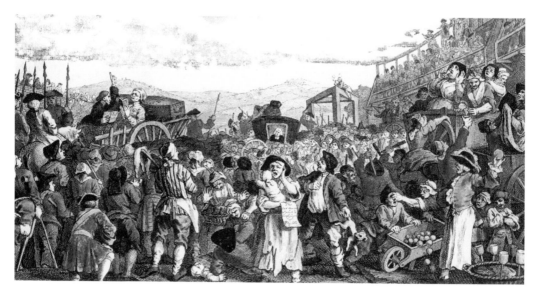

Execution at Tyburn in London.

who observed and later wrote an account of the execution, described what he felt were the feelings of the crowd: 'Farewell poor man, you owe satisfaction to the offended laws of your country, but God bless you! You have rendered an important service to your country, you have taught ministers that they should do justice, and grant audience when it is asked of them.'

The House of Commons voted Spencer Perceval a monument in Westminster Abbey and gave a substantial grant to his widow and children. John Bellingham's body was taken to St Bartholomew's Hospital, again followed by large crowds. Here, his cadaver was 'privately dissected' for medical research, and his remains were buried in an unmarked grave.

Throughout all of this his wife, Mary Bellingham, had remained loyal to her husband, despite continually trying to persuade him to give up his obsessive campaign. Fortunately, the promises made to John that his family would be taken care of proved true. Mary was indeed financially supported by the people of Liverpool. In fact, the local ladies continued to regularly patronise the millinery business that she ran. This meant that she and her children could continue to live securely, if modestly, in the knowledge that they would always be at home in Liverpool, a town of radicals, of community, and of an innate understanding of the need for justice.

This tragic story, and the recent Hillsborough Disaster Inquest verdicts and their aftermath, show us that Liverpudlians being denied justice by an ignorant and callous establishment is nothing new.

THE CHEAPSIDE VAMPIRE

For centuries, from medieval times until the mid-nineteenth century, in towns and villages across Britain it was usual to bury executed criminals and suicides in unconsecrated ground. It was also quite common that such people would be deliberately buried at crossroads on the outskirts of communities. This was because of the superstitious belief that if such people did rise from their graves they would do so as vampires, to drink the blood of their victims whilst also sucking their souls from their soon-to-be lifeless bodies, perhaps then condemning these innocents to also walk the earth as the undead.

There were a number of reasons why crossroads were chosen as burial sites, the main one being the symbolism of the Christian cross, as represented by the intersecting roads or tracks. It was believed that this would permanently trap any restless spirits underground. It was also assumed that if a corpse did manage to dig its way up to the surface again, it would be confused by the four roads and so be less likely to find its way back to its intended victims.

A suicide was also buried face down so that if he did wake and began digging his way out, he would be doing so in the wrong direction, or even the right direction – to Hell! As an additional preventative measure the corpse was often buried with a stake hammered into his back and through his heart, to keep his body secured to the earth.

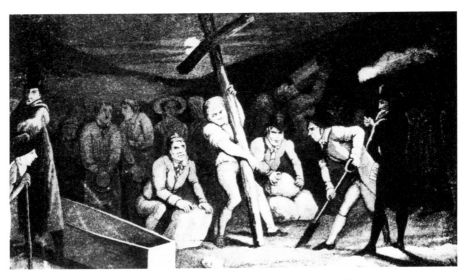

Burying a suspected vampire at a crossroads. (Discover Liverpool Library)

Such irrational beliefs were just as common in and around Liverpool as anywhere else, and especially in what were then more remote local communities. Burying such individuals at crossroads did not end until 1825, following the passing of the Burial of Suicides Act of 1823, which made the practice illegal. However, some years before this, something happened that proved just how close to the town centre of Liverpool such primitive beliefs were still being played out.

On 15 February 1815, at around 6.00 p.m., a man was walking along a narrow street in Liverpool named Cheapside. This was a former medieval track that connected two of the town's original seven streets, Dale Street and Tithebarn Street. The man was alone in the street when someone staggered out of a doorway and stopped in front of him. The walker halted in surprise, but he was even more shocked to see that, apart from a nightcap, the man was entirely naked. He was also clutching his throat, which was bleeding profusely. This man was Thomas Cosgrove and the house was his home.

Cosgrove managed to speak and pleaded with the passer-by to take him inside because he had just strangled his wife and then cut his own throat; clearly though, not enough to kill him or prevent him talking. By this time two other men were making their way along Cheapside and all three helped the still bleeding Cosgrove inside his house. Here they found his wife lying dead on the bed covered in her husband's blood.

A constable was called. He bound Cosgrove's slashed neck and then arrested him. The murderer did not resist as he was wrapped in a blanket and taken into custody.

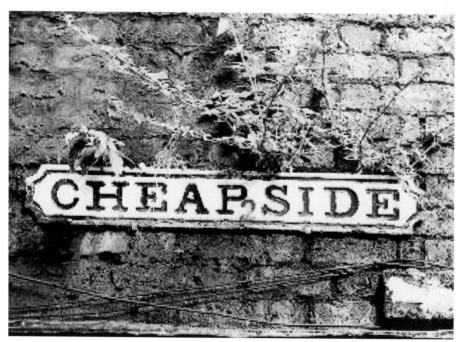

Cheapside, still a narrow alley that runs between two of Liverpool's original seven streets. (Discover Liverpool Library)

Whilst held in the local gaol Cosgrove's throat was sewn up prior to an inquest being held. This returned a verdict of wilful murder, having heard evidence that the Cosgroves had lived on bad terms, and that the woman had 'frequently expressed her fear of being beaten'.

On 28 February, just two weeks after he had throttled his wife, Cosgrove himself died from his self-inflicted wound. The inquest into his case declared him to be a murdering suicide and, as such, he was denied a Christian burial. Instead, his body was taken to a nearby crossroads. Here, he was buried face down at the intersection of the roads. This was to comply with the traditional beliefs and superstitions associated with such cases.

Before long the case of Thomas Cosgrove, and any possibility of him becoming a vampire, was soon forgotten – at least for a while.

However, forty years later, in 1854, Liverpool was undergoing a great expansion. New streets of densely packed tenements, court dwellings, and terraced houses were being laid out in previously outlying districts of the town. It was in that year that sewer pipes were first being laid along Tithebarn Street. Sewers were also being laid in the roads leading off this ancient thoroughfare, so trenches for these were being excavated across this entire area.

When the workmen began excavating at the crossroads junction of Tithebarn Street with Hatton Garden, Great Crosshall Street, and Vauxhall Road, to their horror they found the rotting remains of a male corpse. They were not surprised however,

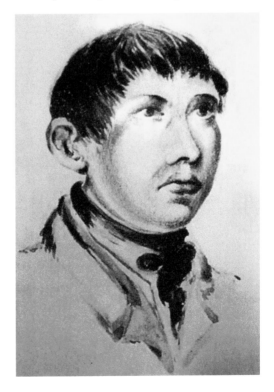

Unknown artist's sketch
of Thomas Cosgrove.
(Discover Liverpool Library)

Left: Digging a trench for a new sewer line.

Below: The location of the burial of the Cheapside Vampire. (Discover Liverpool Library)

and accepted the reasonableness of such a burial. This was confirmed in their minds, as well as those of the public, when inquiries revealed that this was the corpse of Thomas Cosgrove.

A number of local people remembered how Cosgrove had murdered his wife in nearby Cheapside. They recalled too that he had been buried at the crossroads at midnight. It had been expected that he would spend eternity at the centre of a cross and so be forever trapped below ground, but now he had been unearthed!

Thomas Cosgrove was immediately covered over again by anxious workmen as the terrified locals looked on. Then work continued. But, it is said, that the sewer pipe across that road junction in Liverpool city centre has a curve in it as it runs around the remains of 'The Cheapside Vampire'!

THE HOPE STREET BODYSNATCHERS

In January 1822, Revd James McGowan opened a day school for boys on land at the rear of his house on Hope Street. Entrance into the school building, which had a large cellar with separate access, was from the alley alongside the property in Back Canning Street.

As McGowan's stipend was somewhat meagre, to earn extra money he rented out the cellar beneath the schoolroom. The tenant was a man named Henderson who said that his profession was an exporter of fish oil. The naive cleric asked no questions when his new lodger and his two or three workmen insisted on privacy, or even when he soon painted out the cellar windows so that no one could see inside. 'People were entitled to their privacy,' reasoned the schoolmaster, so he left Henderson to his own devices.

Not so the young schoolboys, who allowed their natural curiosity got the better of them. They took great delight in watching as large sacks of salt and

The house on Hope Street behind which once stood the schoolroom and the cellar of 'pickled' corpses. (Discover Liverpool Library)

great wooden barrels were being carried down the steps into the cellar. Then, a few days later, the boys watched just as keenly as the same huge, but now visibly much heavier, casks were brought up again. They were then loaded onto horse-drawn carts waiting in the street.

'What's in them barrels then Mister?' One or two bolder schoolboys asked the workmen one day.
'Fish oil,' came the terse response.
'Is that what the stink is then Mister?'
'Yes,' was the equally blunt reply.
'What's it for then?' The boys continued to inquire.
'It's goin' down to the docks, and then gets shipped up to Scotland. Now, enough of your questions, move on! Leave us to our work!'

Since the arrival of Henderson and his men the boys had begun to notice an unpleasant smell coming from beneath their schoolroom. However, this was now becoming much stronger and more pungent. It wafted up from the cellar and across the yard into the reverend's house. This putrid stink grew worse and worse – especially on hot days – so much so that people now avoided walking down that end of Hope Street altogether. But 'business is business, and rent is rent', thought Revd McGowan. Before long, he, the boys, and the passers-by got used to the smell and life went on – for four years.

Then, as it was approaching evening on 9 October 1826, a carter arrived on Hope Street with instructions to collect a consignment of three very large casks

Barrels being transported to the docks by horse and cart. (Discover Liverpool Library)

labelled 'bitter salts', and to transport them down to Liverpool docks. From there, they were being taken aboard the trading vessel *Latona*, which, in a couple of days' time, was due to set sail for Leith, in Scotland.

It was a breezy evening, which was probably why the smell from the casks was not too bad, and why the crewmen of *Latona* lowered them into the ship's hold without comment or complaint. But this state of affairs did not last. The ship stayed at berth in Liverpool overnight but, in the morning, the ship's crew went to their captain. They complained to him that they had not had a wink of sleep because of the now dreadful stench that was coming from the ship's hold. The captain went down with his men to discover its source and they realised immediately that it was coming from the great barrels.

'Break 'em open lads,' the captain instructed, 'let's see what's makin' such a God-awful reek.'

Covering their noses and mouths with kerchiefs, they set about the lids with axes, only to back away in horror and revulsion when they saw what was inside them: bodies! Naked, human bodies; eleven of them packed in salt.

The police were called, an investigation began, and this led the officers to the house, schoolroom, and cellar in Hope Street. When the policemen made their way down the steps, accompanied by the shocked and innocent Revd McGowan, they could not believe their eyes, or their noses. There, in various states of decomposition, were naked corpses of men, women, boys, and girls; some in barrels and some in heaps on the floor. Most horrifying of all though was a cask full of babies, slowly pickling in saltwater. When the bodies in the cellar were added to the ones from the ship the total came to around thirty-three corpses.

At the subsequent inquest in Liverpool, it was confirmed that, whilst these unfortunate people had all died of natural causes, they had been victims of what

Large casks in the hold of a ship. (Discover Liverpool Library)

Above: The notorious Liverpool Workhouse, the largest in Europe. (Discover Liverpool Library)

Left: Grave-robbers at their nefarious work.

became known as 'The Hope Street Bodysnatchers'. Their bodies had been dug up, in the dead of night, from the graveyard that served the workhouse that then stood at the top of nearby Brownlow Hill. The Metropolitan Cathedral of Christ the King now stands on the site.

This was, at the time, the largest workhouse in Europe, housing an average of up to 4,000 destitute residents. They shared meagre food, cold and inhospitable surroundings, and often hard labour. Wives were separated from husbands and children from their parents, each housed in separate wings of the vast complex.

Medical students dissecting a cadaver.

When inmates died, which they did in large numbers, they were buried in plain coffins, in unmarked graves, across the road in an adjacent burial ground.

Further police investigations into the 'bodysnatchers' revealed that, after being packed in the barrels with the salt as a preservative, the corpses of the deceased inmates were being taken to Scotland to be used for dissection and medical experiments. At the time this practice was not illegal but the public outcry was such that Henderson and his accomplices had to be punished – public opinion was that 'once you were buried you should stay buried'! Henderson disappeared, but his accomplices were tried and sentenced to serve twelve months in Kirkdale Gaol, just to the north of the town centre. They were also fined and eventually released.

The unfortunate victims of Henderson's thriving and profitable enterprise were returned to the graveyard, where a new, large, communal burial pit had been dug. Still in their barrels, these were rolled down planks into the pit, where some of them burst open spilling out their grisly contents. These were then covered with quicklime and reburied. They probably lie there still in the old, lost graveyard beneath the modern Students Union building and car park for the University of Liverpool.

PROPAGANDA AGAINST PROSTITUTION

The most common offences that occurred in the docklands areas of Liverpool, especially during the Victorian era, were prostitution and the crimes associated with it. In the early years of the nineteenth century this had reached epidemic proportions, especially amongst girls and younger women. Something had to be done, and so the authorities in the town decided that radical action was necessary.

In 1827, large copies of a striking poster began to appear on the outside walls of buildings in Liverpool, especially taverns, warehouses, and dockside structures in the more unsavoury sections of the port that were known as 'Sailortown'. These caught the attention of passers-by with a particularly striking heading, set out as follows:

Full and Particular account of the Shocking and
AWFUL DEATH
of Twelve Young Women
Who were Smothered on Monday last, Sept. 3rd 1827, in the Infirmary,
being afflicted with an incurable Malady which they caught of some sailors.

This was an attempt by the authorities and the Church of the day to terrify young women in particular by describing what might happen to them if they fell into prostitution. This was an increasing problem because the expanding population and the lack of available work were forcing ordinary people to find other ways of eking out a living. Robbery and burglary were the common alternatives for men, and selling sex the common alternative for women and girls.

Many desperate young women were being forced, by the poverty of their circumstances or by the brutal desperation of their fathers or husbands, to sell their bodies on the streets and wharves of the town. In typical Victorian fashion there was no official attempt to address the social issues that were

Poverty and starvation often drove women to desperation and into prostitution. (Discover Liverpool Library)

creating young prostitutes, but considerable effort was being made to threaten and to punish those who 'strayed from the path of righteous and seemly behaviour'.

Below the headline on the poster was a vivid woodcut image. This clearly showed twelve young women being smothered to death under a massive quilt or mattress. They were being 'put out of their misery' by three large, well-dressed, uniformed men who were clearly officials of some sort. Underneath the picture was some text and a narrative poem. These described the circumstances of the young girls' plight and the reasons why they had been brought to such a grisly end. I reproduce this below in full, together with the illustration:

A Grecian ship arrived in this port in the month of August last, having about thirty hands on board, when no sooner had the vessel come into the river Mersey, than a number of unfortunate young women went on board to barter both body and soul for a trifling sum of money.

It is the nature of sin to carry along with it its own punishment, and the awful denunciation of God's displeasure not unfrequently commences in this, and terminates in the terrors of another World.

For the foreigners communicated a disease of such an infectious and dreadful nature that it baffled the united skill of the most eminent and experienced of the faculty of Liverpool, and proved too stubborn for any antidote that could be applied in this country.

After every means had been used, without producing the desired effect, the symptoms of this dreadful malady became more and more alarming.

The flesh first turned yellow, then became spongy like a honey comb, and afterwards became black, and began to drop off their bones in large lumps. So offensive was the stench that arose from the putrid state of their bodies that no person, however desirous, could approach their beds or give them any relief.

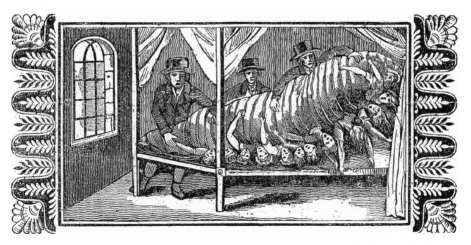

The poster aimed at frightening women out of prostitution. (Liverpool Athenaeum Library)

On Saturday, another consultation of the medical gentlemen connected with the infirmary was held, when, after a most laborious and lengthened conference, they came to the awful question that these wretched young women should be smothered with nitre and sulphur, the easiest and most effectual method of putting a stop to the raging infection.

These unfortunate women's names are,

Jane Williams, aged 18; Mary Frame, aged 16; Elizabeth Watts, aged 15; Mary Evans, aged 20; Margaret Jones, aged 17: Sarah Rich, aged 17; Catherine Howell, aged 17; Elizabeth Bennett, aged 16: Anna Loyd, aged 19; Ellen Harper, aged 17; Sarah Jones, aged 18; and Lydia Neads, aged 16.

Lament, lament, the woeful fate of twelve young females dear,
Who suffered such a death of late, most painful for to hear.

And let all those young females know, who stray from virtues ways,
That Vice did prove their overthrow, and shortened their days

A foreign ship in port arrived, of thirty hands or so,
And twelve gay damsels young and blythe, straightway on board did go.

And there a loathsome, vile disease, infectious and foul,
Did on these twelve young women seize, and raged without control.

The flesh did rot upon their bones, spungy, like honeycomb;
Their dismal, cries, their sighs and moans, would pierc'd a heart of stone.

The doctors to their pain and grief, beheld their suff'rings great,
But could afford them no relief, the plague for to abate.

All human means being tried in vain, but could not mend the case,
To put the sufferers out of pain, an awful scene took place.

The dread infection to destroy, which through the town might spread,
Their precious lives were sacrificed, they smothered were in bed.

Now ponder well this dismal scene, young women all I pray;
Twelve blooming girls of seventeen have thus been swept away.

And left their parents sore to weep, and friends who loved them dear,
Tho' sin and vice your hearts entice, the sting is most severe.

Of course, this incident never actually took place, it was simply a contrived 'horror story' purporting to be the truth. Whether or not the grisly warning poster had the desired effect is not recorded, but that is highly unlikely. As long as there were women in dire straits and desperation, and men equally desperate to buy the only commodity these unfortunate women had available, prostitution in Liverpool, and everywhere else in the world, continued to flourish.

THE MURDEROUS MULVEYS

Tithebarn Street leads into Marybone. This was once simply a cart and packhorse track known as 'the way to Ormskirk'. By the late eighteenth century though, this had become a country lane that a Catholic community had settled around and made their home. They named the lane after 'Mary Bon' – 'Good Mary' – The Blessed Virgin, and it passed beyond the edge of the town through what was then an area of cabbage patches and smallholdings.

By the opening decades of the nineteenth century, this once semi-rural community had developed into a heavily populated area of court dwellings, back-to-back houses, and terraces. The population was comprised of poorly paid or unemployed working-class people, and the environment was squalid and insanitary. This was the start of a time when the taverns and pubs that proliferated around such poorer areas of Liverpool became the focus of whatever social life the people had. These alehouses were also a focus for crime and violence.

Around 1830, Tithebarn Street, but particularly Marybone, had become the haunt of a notorious local family by the name of Mulvey who lived close by in Naylor Street. They terrorised the community by waylaying travellers, especially at night, along this isolated and unlit backwater route. In fact, the entire Mulvey family were footpads and robbers but the father and his two sons were particularly feared by local people. No one seemed to be able or willing to stand up to them, and the local constables were completely unsuccessful in putting a stop to their violent and vicious ways. However, following a spree of unusually cruel attacks that upset the local community more than usual, their next night-time assault did not go the way they had planned.

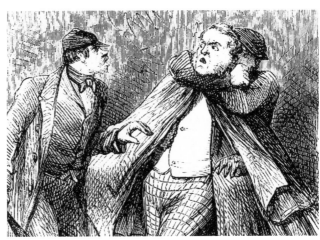

The Mulveys carried out brutal and murderous assaults on isolated Marybone.

From the dark shadows where they lurked, the murderous Mulveys saw a well-dressed, middle-aged gentleman making his way along Marybone. Their unsuspecting victim seemed to be singing to himself and so was completely distracted as he strolled. The Mulveys made their move and set about the lone figure with their cudgels and coshes. However, they were in for a shock because the gentleman, a musician, was much larger and stronger than he had appeared in the darkness. In fact, he so belaboured, beat, and battered the three thugs that he scarred the Mulvey father quite badly. The noise of what had developed into a violent battle, with the musician the victor, attracted a large crowd. Together they were all able to subdue the Mulveys, although the musician had left his new supporters with very little to do to accomplish this.

The three villains were tried, found guilty of assault and of a series of violent robberies, and were all transported to Australian penal colonies where they died in captivity. However, there were other members of the Mulvey family who still stalked the roads and alleys around Tithebarn Street; these were the most feared members of the criminal clan. Thomas, John, and Michael Mulvey were brothers aged between thirty and fifty. They were from Dublin and had only arrived in Liverpool in April 1830, to join the other members of their family already residing in the town. By the summer of that year, they were the scourge of the neighbourhood. The nasty trio went on quite a spree of brutal robberies and murders that were even worse than those of their relatives. However, this time the authorities were more successful in capturing them. The brothers were arrested after attempting to pawn a stolen watch, tried, found guilty of robbery and murder, and sentenced to death.

Thomas, Michael, and John Mulvey were hanged together, side by side, on the large scaffold in Kirkdale Gaol. They were holding each other's hand as the trapdoor fell, but John took over five minutes to die at the end of the hangman's strangling rope.

This notorious family were not the only gang to terrorise the ordinary people of working-class Liverpool. Indeed, throughout the Victorian era particularly, gang crime and violence were rife in certain parts of the town.

Kirkdale Gaol where the Mulveys were executed hand in hand. (Discover Liverpool Library)

CORNERMEN, HIGH RIPPERS, AND DEAD RABBITS

Modern news reports of street violence and knife crime, perpetrated by what we quite rightly describe as gangs of 'callous, mindless thugs', shock and disturb all decent people. Nevertheless, it was the same in Victorian England and nowhere more so than on the dark, narrow, cobbled streets of Liverpool, and for these stories we return to Tithebarn Street.

Criminal street gangs in Liverpool, as well as politically or sectarian-motivated gangs, had been in existence since the early nineteenth century. However, by the 1860s, the densely crowded streets of the town were the violent playground of militant Catholic youths called 'The Hibernians'. They went out on the attack for what might be described as 'ideological reasons'.

Other gangs might go out for the purposes of robbery, whilst some stalked the streets simply for the pleasure they derived from inflicting brutality and violence on completely innocent people.

During the 1870s, the brewing families in Victorian Liverpool, who owned and operated breweries and chains of public houses and beerhouses, were certainly making a great deal of money. A report from 1874 listed 1,929 pubs, 384 beerhouses, and 272 off-licences just in the centre of the town, and these premises helped to create and exacerbate the social and criminal problems of Liverpool. They also gave gangs like the 'Cornermen' an opportunity for violent crime. These groups of thugs loitered outside the doorways of street corner pubs

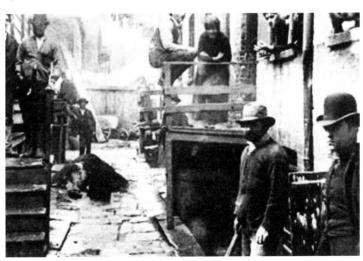

Gangland haunt in the backstreets of working-class Liverpool. (Discover Liverpool Library)

Members of a Corner Gang lying in wait. (Discover Liverpool Library)

intimidating passers-by into handing over the price of at least one pint of ale. If they did not pay then the least they got in return was a beating.

In 1874, a twenty-six-year-old dockworker named Robert Morgan was passing a pub in Tithebarn Street accompanied by his wife and brother. In the doorway stood twenty-year-old John McCrave, who was a Cornerman. With menace he asked Morgan to give him 6d for a pint of ale but the dockworker refused. McCrave immediately punched the other man to the ground.

McCrave was then joined by two other Cornermen who had also been standing in the pub doorway; they were nineteen-year-old Patrick Campbell and seventeen-year-old Michael Mullen. Without any compunction the three youths now brutally and repeatedly kicked John Morgan for a distance of 40 feet along Tithebarn Street before police were able to intervene. By the time their victim had been taken to the Northern Hospital, which was close by, the innocent young docker was dead.

Morgan's brother had bravely tried to pull the youths off John and had managed to punch Mullen to the ground. He then chased after McCrave, who was a fast runner and made his escape. Nevertheless, the ringleader was arrested later that evening and the others were in custody within days.

At their subsequent trial none of the defendants displayed any remorse for what they had done, and all three were found guilty of murder and sentenced to death. Campbell's sentence was later commuted to imprisonment but McCrave and Mullen were hanged at Kirkdale on 4 January 1875. The local newspaper, the *Liverpool Mercury*, reported that McCrave 'showed great terror at the hangman's noose but Mullen remained calm and indifferent throughout'.

By the start of the 1880s, the number of gangs of violent thugs in the town was growing considerably, with names like the 'Regent Street Gang', who claimed that particular thoroughfare as their sovereign territory. Woe betide anyone who,

Trying to fight off an attack by
the Corner Men.

quite literally, crossed their path. There were also the 'Roach Guard Gang'
and 'The Dead Rabbits', both made up of Catholic youths. They were thieves
and robbers who were also exceptionally territorial. They simply enjoyed
fighting and the more brutal the battle the better. They fought with other gangs
over territory and status or 'just for the hell of it'. Any ordinary passer-by who
happened across such a battle could suddenly find himself drawn unwillingly into
the mêlée, and getting stabbed, mutilated, or worse as a result.

Both of these gangs had counterparts by the same names operating in the
streets of New York, as did many more from the town. This means that these
disaffected and violent youths, coming over from Ireland after the Great Potato
Famine in the 1840s, were then taking their prejudices, practices, and pastimes
over to the New World from Liverpool.

Then there were the 'Logwood Gang' who, as their name suggests, carried
long, heavy sticks or small logs as their weapons of choice, using them as cudgels
to belabour their victims about the head and shoulders.

Perhaps the most notorious of all the Liverpool gangs were 'The High Rip
Gang' also known simply as 'The High Rip'. Their particular targets were dockers
and dockworkers, and they were quite 'professional' in their methods. After
identifying their target, they might track him for days or weeks just to establish
his routes and routines. Then, and especially on pay days, they would pounce,
assault, and rob these innocent workmen. They thought little of using the severest
levels of violence on their victims, even hacking or kicking them to death. These
gangs terrorised the town, and scandalised the nation.

A typical street gang.

Liverpool also had its child gangs, often organised by older, more experienced thieves, not unlike the 'Bill Sykes' or 'Fagin' characters in Charles Dickens's *Oliver Twist*. Mostly, the gang members were young boys who were following the loutish patterns set by their older brothers, or even their fathers. Whilst some were violent and assaulted and robbed people, mostly they were burglars: such gangs as 'The Housebreakers' and 'The Lemon Street Gang'. This latter gang in particular was made up of family members or gangs of 'mates'. Many of these youngsters had run away from home, preferring a life of adventure on the streets of Liverpool. Conditions at home must have been dreadful though if that was their chosen way of life! But the gangs did not all get their own way, least of all the children. More often than not, and sooner or later, the law caught up with them. When it did, it was vicious in its retribution.

Teenagers would be sentenced to time in a main prison. However, children and younger boys could be sent, for a number of years, to 'Industrial Schools' such as the notorious establishment at Kirkdale that once stood on Westminster Road. Here the regime was strict, punishments were brutal, and living conditions were harsh.

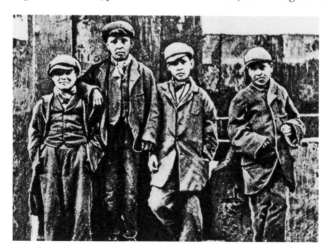

Members of the Lemon Street Gang. (Discover Liverpool Library)

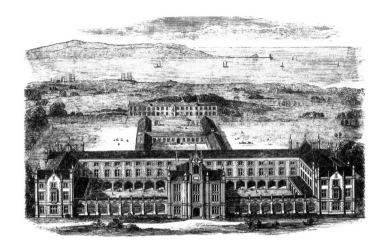

Kirkdale Industrial School. (Discover Liverpool Library)

Alternatively, young offenders could serve time aboard special training ships moored in the River Mersey. Amongst these vessels were the *Akbar*, for the reform of Protestant boys, and the *Clarence*, to set Catholic boys back on 'the straight and narrow'. There were also HMS *Conway*, for training young officers for the Royal Navy, and TS *Indefatigable*, for training and reforming boys from especially poor backgrounds.

Whilst the boys slept in rows of hammocks not cells, conditions on board these vessels were harsh indeed. There was also the added inconvenience of being on board a floating, tethered, confined, wooden institution where ruthless discipline was a way of life. All of this was perfectly in tune with the desire for punishment and penitence so prevalent in Victorian times.

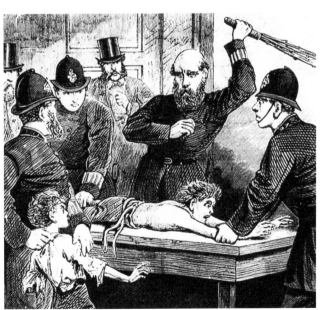

Police flogging young street gang members. (Discover Liverpool Library)

As well as incarceration flogging was used on younger offenders with either a set of birch rods or a cat-o-nine-tails. A 'birch' was, in fact, a number of long, leafless hazel or willow twigs bound together along only part of its length. This could often be up to 4 feet long. It was usually administered, with considerable force, on the bare buttocks of the offender, although sometimes on the bare back or shoulders.

The 'cat' was a much more vicious instrument of punishment. This consisted of three, five, seven, or nine lengths of plaited cotton cord or thin leather, each strand with a knot tied in it near the end. Again, this was always administered on bare skin, usually the buttocks but again also the back and shoulders. This is where the expression 'not enough room to swing a cat' comes from.

Of course, flogging was also used on adults, and indeed, flogging of men was still being carried out as late as 1962, although public flogging was abolished in 1830. The birching of young people was only abolished in 1948, except on the Isle of Man, where it was in use until 1976.

Naturally, the death penalty was fully in force, and not just for murder, but for pick-pocketing, sheep stealing, burglary, and many other offences. Children too, often as young as seven years old, could be executed by hanging.

Neither hanging nor flogging seemed to deter the thugs who were members of Liverpool's vicious street gangs of whatever age. These punishments kept being meted out, but the gangs kept forming and continuing their violent ways. This was the case until the outbreak of the First World War: now these young men were being sent overseas, in uniform, when they would experience for themselves what it was like to be on the receiving end of vicious assaults, only this time by men with bullets, mortars, bayonets, and mustard gas.

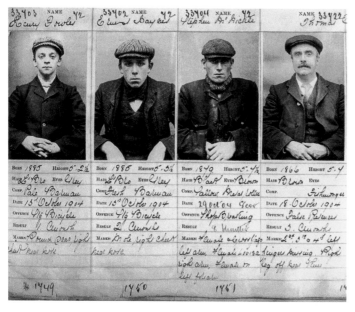

Police photographs of street thugs. (Discover Liverpool Library)

FIRE IN THE MENAGERIE

Whilst no people suffered death or injury in my next story, there were scores of victims who did; it is just that they were all animals. Were these casualties of a deliberate and criminal act or simply of a tragic accident? Whatever is the truth, the 'Great Menagerie Fire' was a sensation.

The people of Liverpool and Merseyside have always enjoyed thrilling and unusual entertainments, but they especially liked zoos. In Liverpool alone, between the early 1800s and the late 1930s there were at least six of them. These all had to be supplied though, with a wide range of creatures that were exciting and novel enough to entertain and satisfy the demanding tastes of the paying public. Fortunately for the zoos and the people, in the whole field of animal trading, few men were more significant and able than Liverpool-born William Cross (1840–1900).

"CROSS,"

" King of Wild Beast Merchants."

ELEPHANTS, TIGERS, LIONS, ZEBRAS, &c.

GREY AFRICAN PARROTS.

10,000 PAIRS OF SMALL BIRDS.

FRESH ARRIVALS DAILY.

Largest Trading Zoological Establishment on the Earth. Send for Requirements. Trade Supplied.

CROSS'S

TRADING MENAGERIE.

ALWAYS SOMETHING NEW.
HUNDREDS OF ARRIVALS WEEKLY.

HUNGARIAN PARTRIDGES.

 Birds and Animals . . Stuffed and Preserved.

NATIONAL TELEPHONES, 6491 AND 7427.
TELEGRAMS AND CABLEGRAMS, "CROSS, LIVERPOOL."

LIVERPOOL.

Cross's Menagerie leaflet.
(Discover Liverpool Library)

Already a renowned animal importer, from around 1879, Cross established a new, major base of operations at 'Cross's Menagerie and Museum', in a large warehouse at the corner of Rigby and Earle Streets in Liverpool. This was near to St Paul's Square, which is now at the heart of the city's modern commercial district. Cross based his business here because it was close to the docks and to the ships that brought in, and exported again, his live wild animals, birds, and reptiles.

Cross was one of the most important and successful importers of animals, and he supplied these to zoological gardens and private collections all over Britain, Europe, and around the world. He employed his own hunters in the more far-flung countries so always ensured a ready supply of some of the most exotic creatures. He also advertised extensively and had agents operating across the globe.

So successful was his business that Cross decided to open up his vast warehouse to the paying public, including its hundreds of cages and compounds, and he made a great deal of money as a result. This was because he was a showman at heart, who certainly knew how to appeal to the Scousers' passion for the thrilling, the bizarre, and the extraordinary.

He exhibited a wide range of creatures at his premises, such as bison, giraffes, and rhinos, which most people marvelled at because they had only ever read about them, or seen them in pictures. Thousands of people were also drawn to his great menagerie to learn how to ride zebras and to witness exhibitions of apparently fearless men wrestling with lions. They could also gaze in wonder at that rarest of specimens, advertised as 'a white elephant from Siam' – although rumour had it that Cross simply painted an ordinary elephant with at least fifty coats of a mixture of whitewash and plaster of paris!

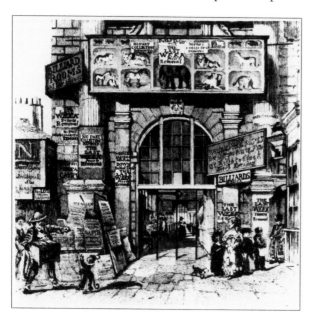

The main entrance to
Cross's Menagerie.
(Discover Liverpool
Library)

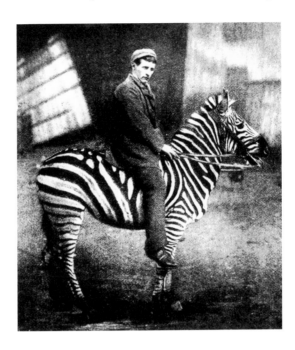

Learning to ride a zebra!
(Discover Liverpool Library)

On 25 August 1898, there was a serious fire at Cross's Menagerie. Reporting this disaster, the *London Pall Mall Gazette* newspaper stated:

> The terrible-scene in the early hours of yesterday cannot be imagined, except by one who has seen a prairie fire or a jungle conflagration. The collection of animals at this place is one of the most remarkable in any civilized country, and it is constantly changing ... The caged beasts themselves gave the alarm, their keen smell detecting the fire at the first outbreak, and when the flames' took hold of the building their screams and roars of terror must have been appalling.
>
> The poor brutes were mostly suffocated, for you cannot deal with lions and tigers as you would with horses, and open the doors and let them out. Either the cages must be moved bodily or the occupants abandoned, and the fire took such rapid hold that there was no time for heroic measures. The loss in lions, tigers, and leopards was considerable; all being burned to death; but a baby elephant, it is interesting to know, escaped unharmed.

The fire spread so quickly, and the great clouds of smoke were so blinding and suffocating, that all attempts at rescue were beaten back. Within thirty minutes of the blaze breaking out over half of the building's massive roof fell in.

Among the eighty or so creatures that either choked or burned to death were four lions, five leopards, a Bengal tiger, a jaguar, an adult puma, a black opossum, twenty-eight prairie marmots, and a crested eagle hawk. Also killed were a vulture, two hyenas, three cheetahs, a peccary, four rare foxes, two Virginian owls, two very rare Northern China owls, and two eagles.

During the inspection of the building, after the fire had finally been extinguished, the full tragedy began to be revealed. Most of the animals had been seared beyond recognition in the blaze, their limbs in many cases being burnt entirely away. It was also clear that one of the lions had made a frantic effort to escape before being overcome. The remains of its forepaws were found protruding through the bars of its cage, against which its head was pressed with obvious force and, as the newspaper described, 'showing the frantic strength which he must have used in his last mighty effort to escape the flames'.

However, some animals were found to be still alive, if barely. These included three hyenas, although each was severely burned about the head. One was so injured and in such agonised distress that it was decided to kill it. When the cage door was opened the demented creature began biting everyone and everything around it. The animal immediately bolted through the door but one keeper managed to leap on it and pin it down by its hind legs. This enabled the speedy intervention of two other keepers, who quickly put a noose around its neck and throttled it, finally putting it out of its agonised misery. However, four cassowaries, a black bear, and a kangaroo were rescued, terrified and soaking wet from the fire-hoses, but otherwise completely unharmed.

Quite a number of animals had managed to escape the building during the fire, not just the baby elephant. These wreaked havoc in the surrounding streets before all being eventually recaptured – luckily, without injury to themselves or to members of the public. Just as fortunately the menagerie was fully insured and so was completely rebuilt and restocked.

Naturally, questions were asked about the cause of the mammoth conflagration. Was it a simple accident or was it the result of neglect or incompetence by

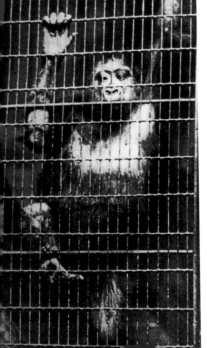

Above: Lions in the menagerie before the great fire. (Discover Liverpool Library)

Left: One of the most popular animals on display: the baby gorilla. (Discover Liverpool Library)

a member of staff? Was the fire set with malicious or criminal intent? Was it deliberately started to defraud the insurance companies? They certainly paid out, so must have been satisfied that the claim was legitimate. However the fire was started, within a year or so it was 'business as usual' for the menagerie and, in the 1902 edition of the 'Stranger in Liverpool', a popular and thoroughly detailed tourist guide to the city, a report stated:

> Cross's menagerie is situated at the corner of Rigby Street, off Old Hall Street (which is reached by crossing the Exchange Flags behind the Town Hall) and within a stone's throw of the Exchange Station, is this depot, undoubtedly one of the most complete trading menageries in the world ...
>
> Beasts, birds, reptiles, and other representatives of the lower creation are dealt with, and so varied is the business that the proprietor boasts of his readiness to supply, on the shortest notice, anything with life in it from a humming bird to an elephant.
>
> The menagerie is open to the public daily from 10.00am to 5.00pm, at a charge of 6d. per head, and, as many of the magnificent animals are constantly going through a course of training, a visit to the establishment will prove both interesting and instructive.

After William Cross retired the business was then managed by his sons, William Simpson Cross (1873–1920) and James Conrad Cross (1879–1952). It is not clear when Cross's Menagerie closed, but it was certainly still operating in 1911. William Jnr now had overall responsibility for the business and, during the 1900s, he expanded the family's interests by renting the former mansion house and riverside estate of slave trader and railway pioneer John Moss (1782–1858), at Otterspool in south Liverpool.

Here, around 1914, he opened a new zoo. Amongst its attractions were a toothless, clawless, one-eyed lion, and an entirely bald-headed, bad-tempered badger. These animals, together with llamas, a buffalo, and many others from his collection, were allowed to wander freely around the grounds and amongst the paying public – there was no health and safety executive in those days you see! This zoo closed in 1925, when Liverpool Corporation bought the Otterspool estate to convert it into the public parkland that is now known as 'Otterspool Park and Promenade'.

There are no longer any zoos or menageries in Liverpool, the nearest now being at Chester Zoo, and the triumphs and tragedies of William Cross and his sons are now only a memory. However, there is a thrilling safari park on the estate of the 19th Earl of Derby, at Knowsley to the east of the city. At this attraction Merseysiders' continuing passion for exciting animals can still find satisfaction in the twenty-first century.

THE TELLTALE BROOCH

Cora Turner was born in 1873, in Brooklyn, New York, and she was a mediocre theatrical and music hall singer who preferred to use her stage name of 'Belle Elmore'. It was in the USA that Cora met Hawley Harvey Crippen (b. 1862), also an American, who was a homeopathic doctor and an ear and eye specialist. He was also a widower with a small son and, in 1894, Crippen and Cora married, then, in 1897, they moved to London. Here, the doctor set up as a distributor of patent homeopathic medicines whilst Cora, now openly being referred to as Belle, took what work she could singing in music halls, smaller theaters, and taverns. Belle was a very flamboyant and loud woman who was fond of collecting diamond jewellery and wearing extravagant, pink, frilly gowns. She also liked to drink and flirted openly with men in bars. She had numerous casual affairs that

Above left: Cora (Belle Elmore) Crippen on stage. (Discover Liverpool Library)

Above right: Hawley Harvey Crippen, the seemingly meek homeopathic doctor. (Discover Liverpool Library)

she made no effort to keep secret. Cora (Belle) Crippen was also a very dominant personality who quite relentlessly nagged and bullied her husband.

Hawley Crippen was a small and very mild-mannered man. He was quite an insignificant-looking character with a high, bald forehead; a thick moustache; and rather bulbous eyes. He wore gold-rimmed spectacles and always dressed smartly, if very conservatively.

Regularly humiliated by his wife (often in public), the diminutive doctor soon turned his attentions to other women, in particular, from 1908, to his twenty-eight-year-old secretary, Ethel Clara Le Neve (b. 1863). Belle discovered this and threatened to leave him penniless – despite her mediocre talent she was actually earning good money and managed the household accounts.

On 31 January 1910, Belle held a party in the Crippen family home at No. 39 Hilldrop Crescent, Holloway, in London, but very soon afterwards she disappeared. The singer was well known and popular and before long her friends were asking where she was. Her husband claimed that she had gone home to America, but then told people that she had died there, and that her body had been cremated in California. Then he moved his girlfriend, Ethel, into his house. Soon, she began to go about wearing Belle's stylish clothes and exotic jewellery.

Meanwhile, a close friend of Belle, Dublin-born but Liverpool resident Mary Egerton (dates unknown), also known as 'Ma Egerton', was on a business trip to

The Crippen family home in Camden Town, London.

London. Mary was a well-known and highly respected theatrical agent who also ran three popular pubs in Liverpool: Egerton's, in Cases Street; The American Bar, on Lime Street; and The Eagle (now Ma Egerton's Stage Door), behind the city's Empire Theatre.

As she walked along a street in London, Mary, by chance, happened to see Ethel Le Neve, whom she recognised. Ethel did not notice Mary, who clearly saw that the lover of her friend's husband was wearing one of Belle's glamorous frocks, adorned with the singer's favourite piece of jewellery. This was a very striking, distinctive, and valuable 'starburst brooch'. Its design featured a gorgeous pendant whose black centre stone was cut with a cluster of diamonds, and from which extended a ray-beam design of inlaid smaller diamonds.

Mary had not believed the story about Belle Elmore being back in America, and now her suspicions were really aroused. The knowledgeable and worldly impresario contacted Scotland Yard, who immediately began an investigation into the disappearance of the music hall singer. Doctor Crippen was interviewed at his home by Chief Inspector Walter Dew (1863–1947). It was to the detective that Crippen admitted that he had actually made up the story about his wife having died in America. He said that he had invented it because Belle had really run off to the USA with her latest lover, a music hall actor named Bruce Miller. Crippen said he had told people the story to save his own embarrassment.

Mary (Ma) Egerton (standing third from right, back row) with some of her friends and clients. (Courtesy of Iain Hoskins)

Ma Egerton with some of her happy customers during the Second World War. (Courtesy of Iain Hoskins)

After a quick search of the house Dew said he would probably return to further question the doctor and then he left.

Crippen and Le Neve panicked and immediately fled to Brussels in Belgium where they stayed for a night. The following morning they travelled to Antwerp where they boarded the Canadian Pacific transatlantic liner SS *Montrose*, bound for Canada. Crippen travelled in his normal clothes but Ethel was disguised as a young man.

In the meantime, Chief Inspector Dew returned to the Crippen house to find only the maid at home. At this point he had no idea whether Belle was dead or alive, so he made a much more thorough search to see if he could find any trace of her or any evidence of foul play. He and his detectives scoured the building from top to bottom four times. Buried under the floor of the coal cellar and wrapped in a pair of men's pyjamas, he discovered, according to reports, 'a compact mass of animal remains which, on expert investigation, proved to be the greatest part of the contents of a human body'. There was no head, all the limbs were missing, and there were no bones, except for what appeared to be part of a human thigh.

A warrant was issued by the Metropolitan Police for the arrest of the doctor and Miss Ethel Le Neve, and an international alarm for the fugitives was sent out across Europe requesting any information about them.

Henry Kendall, the captain of the *Montrose*, whilst reading a newspaper in his cabin, saw a report about what had now been dubbed 'The London

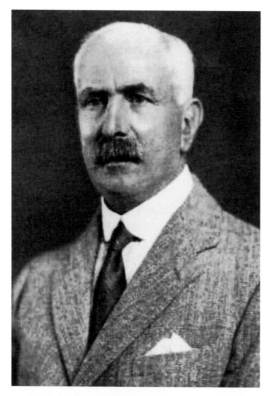

Left: The murderer's relentless pursuer: Chief Inspector Walter Dew, of Scotland Yard.

Below left: The hunt for Belle Elmore's body.

Below right: The human remains discovered in Crippen's cellar.

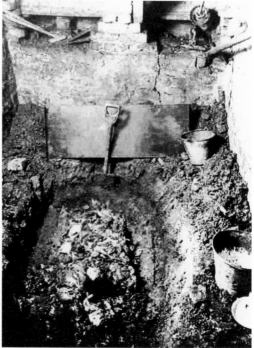

Cellar Murder', and the missing fugitives. He became suspicious of two of his passengers, especially as he had seen the 'apparent' males affectionately holding hands. Captain Kendall immediately sent the world's first wireless telegraph message used to track fugitives, which read:

> Have strong suspicion that the London Cellar murderer and accomplice are amongst saloon passengers. Moustache shaved off, growing a beard. Accomplice dressed as a boy, voice, manner, and build; undoubtedly a girl.

In the meantime, Chief Inspector Dew boarded a faster ship, the SS *Laurentic* and, on 31 July 1910, was waiting at the quayside when the *Montrose* docked in Canada. Crippen and his lover were arrested as soon as they stepped onto the gangway and were immediately brought back to Britain, sailing to Liverpool aboard SS *Megantic*. From the city they were taken to London by express train.

Crippen went on trial accused of his wife's murder at the Old Bailey in London on 18 October 1910. Appearing before the Lord Chief Justice, Lord Alverstone (1842–1915), the trial lasted for four days; Ethel was tried separately as his accomplice.

In evidence, the human remains unearthed by the police were declared to be female, and were found to contain the toxic compound hyoscine hydrobromide. It was also proved that the doctor had bought a quantity of this drug and that it was this that was believed to have been the cause of death of the headless, limbless victim.

Even though he claimed that he had bought the drug for one of his homeopathic remedies, the doctor was found guilty of murder, with the jury taking only twenty-seven minutes to reach their verdict. The doctor was hanged

Chief Inspector Dew leads Crippen off the ship.

Crippen and his mistress on trial.

at Pentonville Prison on 23 November 1910, and he asked that a photograph of Ethel be buried with him. His request was granted. Ethel Le Neve was acquitted of complicity in the murder.

Changing her name to Miss Allen, on the morning that Crippen was being hanged, Ethel Le Neve sailed for New York, and then travelled on to Toronto. In memory of her executed lover she changed her name again, this time to Ethel Harvey. Sometime during the First World War she returned to London, where she married a clerk by the name of Stanley Smith. They had a number of children, and Ethel died in 1967, at the age of eighty-four.

After the trial and Crippen's execution, Belle Elmore's possessions, clothing, and jewellery were auctioned off. Amongst these items was the murdered woman's famous brooch, which she had called her 'rising sun', and which had aroused the suspicions of Ma Egerton. Charles Fry, a Wallasey pawnbroker, bought the brooch and put it on display in the window of his shop at No. 242 Liscard Road. What eventually happened to the 'telltale brooch' remains unknown.

HMS *THETIS*: A FLOATING TOMB

On 1 June 1939, a few months before the outbreak of the Second World War, the Royal Navy submarine HMS *Thetis* was undergoing her sea trials in Liverpool Bay, just off the North Wales coast. Built at the Cammell Laird Shipyard in Birkenhead, her designers, her crew, and the navy were confident that this would be successful and straightforward, but this was not to be.

As she sailed into the bay, and because of an oversight, her No. 5 torpedo tube had been opened to the sea. This would not normally have been fatal except, owing to poor design and a faulty valve, the No. 5 torpedo hatch to the inside of the vessel was also opened by mistake. A torrent of water poured in, overpowering all the men inside and making the closing of the hatch impossible. The forward compartments of the submarine flooded, and so she lost trim and plunged bow-first to the sea bottom in 165 feet (50 metres) of water. Nevertheless, the submarine managed to partly resurface with her tail section and rudder sticking up out of the water. However, the rest of her remained submerged with the entire crew still alive inside.

All rescue attempts failed and of the ship's compliment of 103 men, of whom fifty-three were her own crew and fifty were technicians and observers, only four men managed to get out through an escape hatch. This left ninety-nine men trapped aboard. The escapees were hauled aboard the destroyer HMS *Brazen*, begging for an urgent rescue of their comrades.

By this time around twenty-six vessels were circling the submarine, crammed with navy personnel, salvage experts, and heavy cutting equipment, but they were ordered by the Admiralty to wait and stand off from the submarine.

HMS *Thetis* setting off for her sea trials in Liverpool Bay. (Discover Liverpool Library)

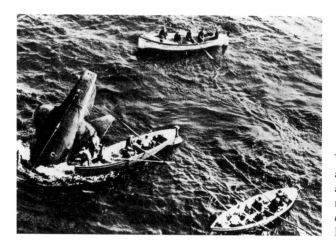

The stern of *Thetis* juts above the water as boats assemble to mount a rescue of her trapped crew. (Discover Liverpool Library)

Throughout this time knocking was clearly heard from inside *Thetis*. This was coming from the trapped submariners desperately wanting to confirm that they were still alive, whilst they no doubt confidently waited to be saved.

The men aboard the rescue ships were indeed eager to help those trapped in the submarine, but were still not being given permission to do so. Despite their angry pleas, no one explained to them why they could not simply cut through the exposed hull of the vessel to extract the men. As the divers, salvage crews, and doctors became increasingly anxious the knocking from inside *Thetis* became weaker and less frequent. Before long, it simply faded away altogether.

After fifty hours trapped inside their submarine in Liverpool Bay all the men inside were dead of carbon dioxide poisoning. They had been killed by the very

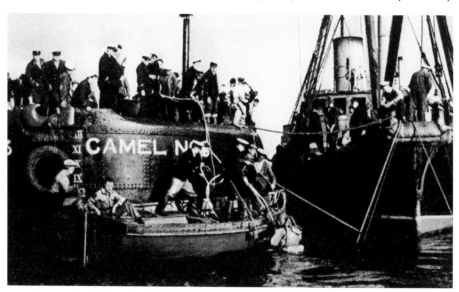

The diver goes down to see if he can rescue any of the men.

breath they had exhaled. This is a slow and excruciatingly painful way to die, and HMS *Thetis* was now nothing more than a metal tomb. The deaths of those trapped inside became the Royal Navy's worst peacetime submarine disaster.

Still in the water but now a floating mass coffin, it was not until 23 August 1939, almost two months later, that a major attempt to salvage the vessel was undertaken. During this operation, which was ultimately successful, deep-sea diver Petty Officer Henry Otho Perdue died of a severe attack of the bends, and he will forever be remembered as 'the hundredth victim' of the 'Thetis Disaster'.

On Sunday 3 September, the same day that war was declared, the submarine was towed to Moelfre Bay, Anglesey, and grounded on shore. Those bodies that had not already been removed by the salvage team were now brought out, to receive a belated naval funeral with full honours. Forty-four of those lost aboard the submarine were interred in a mass grave in Holyhead.

Thetis was soon afterwards taken back to Birkenhead where, after an extensive rebuild, she was recommissioned as HMS *Thunderbolt*. This ill-fated submarine sailed on her first operational patrol on 3 December 1940. But, on 14 March 1943, she was depth-charged and sunk by the Italian ship *Cicogna*, with the loss of all hands.

It was not until 2009 that details surrounding the Thetis Disaster became known. It was in that year that previously secret government papers were made public. These confirmed that rescuers could have saved all the trapped men in just five minutes by cutting air holes through the ⅝-inch-thick steel hull. A larger hole could then have been cut to release them.

Relatives of the trapped men anxiously waiting for news. (Discover Liverpool Library)

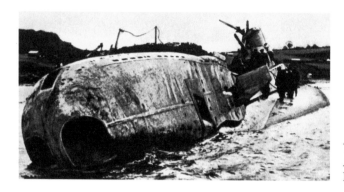

Thetis beached at Anglesey. (Discover Liverpool Library)

The Admiralty had simply refused to allow the rescue because the hull would have been permanently weakened. At that time, and with the Second World War looming, saving the submarine was deemed more important than saving ninety-nine human lives.

After the war, on 7 November 1947, a memorial was dedicated at the gravesite in Holyhead. Also, a memorial plaque to HMS *Thetis* and her crew is now mounted at the foot of the stairwell in the tower of St Mary's Church in Birkenhead. This stands near the medieval priory and overlooks the River Mersey and the shipyard where *Thetis* was built.

As one walks up the staircase to the top of the church tower the walls are lined with nameplates, each one bearing the name of one of the lost men, including Petty Officer Perdue. This tribute acts as a stark reminder of just how totally callous and unnecessary were the deaths of these lost submariners and engineers. The deliberate inactions of the Royal Navy could indeed be said to have been murderous.

Some of the individual memorial plaques mounted on the stair rail inside the tower of St Mary's Church in Birkenhead. (Discover Liverpool Library)

THE MAN IN THE IRON COFFIN

During the Second World War Merseyside suffered massive aerial bombardment by the Germans, and Liverpool was the most heavily bombed town or city in Britain outside London. In fact, during the May Blitz of 1941, the city centre was devastated. Liverpool and its suburbs were pockmarked with bombed buildings and craters for decades after the end of the war.

During one of the Nazi aerial assaults a bomb blast created such a deep crater that the explosion revealed something that had lain long buried. At the corner of Great Homer Street and Fulford Road a rusting iron cylinder was exposed. This was just over 6 feet long and around 2 feet wide, and seemingly completely sealed at both ends. But, because the authorities had more pressing matters to deal with as war was still raging and Hitler was determined to bomb Liverpool into oblivion, the cylinder was simply left where it lay.

It soon became a play place for local children; a temporary seat for weary passers-by; and Gypsies used it as a workbench on which they made artificial

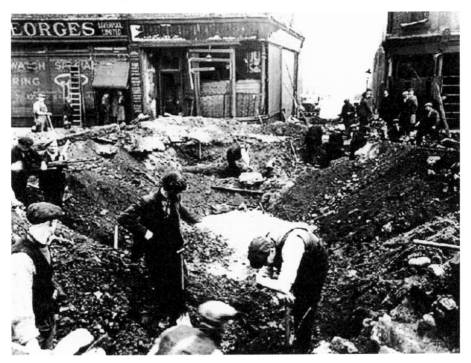

A typical Second World War bomb crater.

flowers to sell around the surviving streets and houses. The cylinder became so familiar that no one seemed to give much thought to it, until a few years later.

Curiously, it was on Friday 13 July 1945 that some local children were playing 'tick' and 'hide and seek' around the bomb crater. Hiding from his playmates behind the large metal cylinder, a nine-year-old boy named Tommy Lawless noticed something poking out of the end of it. Taking a closer look, he discovered that the large tube had opened up at one end and that a boot was now sticking out of it.

Calling to his mates, their game was soon replaced by shared fascination, as Tommy took hold of the boot and pulled. To his surprise it came away quite easily but, and to the shock of all the children, it revealed a human leg and foot bones.

Fighting their natural instinct to further explore their macabre discovery, the boys simply stood guard over it whilst Tommy ran off to find the local constable. A few minutes later the boy returned with the local beat bobby (then much more numerous than they are today), PC Robert Baillie, who took charge of the now even more intriguing object. He arranged for its immediate removal to the city mortuary.

Thoroughly and professionally examined, the cylinder was seen to be a piece of sheet iron that had been formed into a tube and then riveted together along its length. There was a lid at one end, which had also been riveted in place. The other end had been pressed together, rather like the end of a tube of toothpaste, but, for some reason, this had now come apart to reveal its grisly contents.

The iron tube in which the mysterious body was discovered.

When the tube was then cut open, inside was found an immaculately dressed male body in an advanced state of decomposition. The clothes that the cadaver was wearing seemed to be of nineteenth-century origin and comprised a frock coat; narrow, striped trousers; a plain shirt; a thin bow tie; and his boots were clearly of Victorian design.

The man had been lying, at full stretch, on some form of hessian cloth or sacking and with his head resting on a brick. The pathologists could not find any obvious cause of death and were completely baffled. What they did ultimately discover though, only added to the mystery.

Close inspection confirmed that the body was of a male of middle age and reasonably healthy, judging by the condition of his skeleton, teeth, and remaining flesh and hair. He was around 6 feet tall and had probably been lying underground for around seventy years. Otherwise, there was nothing else to explain who he was, or how and why he had ended up in an iron coffin – nothing that is, until the pathologist started to go through the pockets of the mystery corpse's clothes.

The famous and respected Preston-based forensic scientist Dr James Brierley Firth discovered a set of keys, a hall-marked signet ring, and two appointment diaries dating from 1884 to 1885. He also discovered a set of papers stuck together with the oozing residue of the putrefying cadaver. With considerable difficulty these were cleaned up, prised apart, and spread out, and there were around thirteen sheets in all. These seemed to relate to a Liverpool company named 'T. C. Williams & Co.', of Leeds Street, and one of the papers was a letter addressed to Mr Williams personally.

On 19 July 1945, an inquest into the mystery man was opened by the Liverpool Coroner, but immediately adjourned whilst inquiries continued. Police soon discovered that such a company had indeed existed in Liverpool, around 1880. This had been a firm of oil traders owned by a Thomas Cregeen Williams, whose home address seemed to have been in the Anfield district of the city. Investigations also revealed that the company had been in severe financial trouble, but no record of the death of Thomas Williams could be found. This led the police to the inevitable conclusion that the corpse in the iron coffin was Thomas Williams himself.

However, this could not be established conclusively so, on 31 August 1945, the coroner closed the inquest by recording an open verdict on 'the death of an unknown man sometime around the summer of 1885', but the cause of his death could still not be established. As a result, to this day some questions remain unanswered:

Was the body definitely that of Thomas Cregeen Williams? If not who was it?
How did he die? Was it suicide?
If so, how did he do it, and who sealed him into his metal tube?
Was it murder? If so, by whom, and why?

A recent photo showing the site of Fulford Road. (Discover Liverpool Library)

Why such an elaborate coffin?

Why was he buried so deep, and so anonymously with no marker or record?

And finally, who buried the heavy iron tube with its grim contents?

In due course the remains were cremated and buried in an unmarked plot in a Liverpool cemetery, but what happened to the tube is not recorded. Whatever, it is unlikely that we shall ever discover the identity, or the circumstances surrounding the life and death of the man in the iron coffin.

THE MASS GRAVES OF OLD SWAN

Whilst this next entry is not about any obvious murders, the story does certainly have something of the 'misdemeanour' about it. The incident took place in the suburban district of Old Swan, to the east of Liverpool town centre. Here stands the beautiful Roman Catholic Church of St Oswald, which was designed by Augustus Welby Pugin (1812–52). This opened in 1842, and was the first Catholic church in the north of England since the Reformation to have been built with both a tower and a spire. It is also in St Oswald's that the first Roman Catholic Bishop of Liverpool, Bishop George Brown (1784–1856), is buried.

In the autumn of 1973, work began on excavating a plot of open land next to the church. This was to lay the foundations for new infant and junior schools, to be attached to the church and to bear its name. However, just as digging was about to commence, the parish priest at that time, Father McCartney, warned the foreman that there might be some unmarked graves at one end of the site. So, before any more work could take place, the Home Secretary had to sign an exhumation order. Then the mechanical diggers moved in.

With great care they began moving earth and, sure enough, an unmarked coffin was discovered, at a depth of around 15 feet (5 metres), soon followed by another one. With the greatest of respect the workmen laid these side by side as digging continued. Then, another coffin was dug up, and another, and another, as the digging process was now speeded up. In fact, and to the amazement of

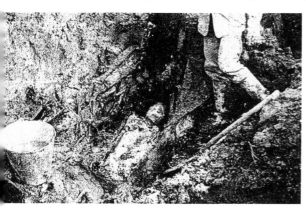

Above: Bodies being exposed at Old Swan. (Discover Liverpool Library)

Right: St Oswald's Church in the district of Old Swan in Liverpool. (Discover Liverpool Library)

everyone on-site, and from an area of only around 40 square yards, a total of 3,561 coffins were eventually exhumed. These were then laid out, in rows, on the building site.

In fact, they were now being laid out above ground just as neatly and orderly as they had been buried beneath it, except that they had originally been interred up to sixteen coffins deep in places! This seemed to indicate that the burials had taken place as a single operation but Father McCartney was as surprised as the workmen were. He had known anecdotally of one or two unmarked graves but knew nothing else about them at all. Neither did he know who the bodies were or why they had been buried unmarked, and in that particular location. He could find no written records of the burials in the church archives, and certainly not of over 3,000 people!

I have heard one story – although how true it is I cannot say – that at one point during the hurried process of exhumation events took a particularly ghastly turn. It seems that as the coffins were being hauled up out of the ground the perfectly preserved corpse of a young woman tumbled out of one of them. It was raining and the earth was a muddy quagmire. The woman's body slid into the mud but, almost as soon as it did, her previously clear features began to disintegrate, as did the rest of her body. This horrified the men digging up the bodies but it became worse as the rain got into more of the coffins. These now broke open too, emptying more decomposing and disintegrating cadavers into the mud, all around the horrified workmen. I have no information about how they dealt with this truly unpleasant turn of events.

Naturally, as soon as the first bodies had been discovered the Liverpool Coroner had been informed. But now came an urgent instruction direct from

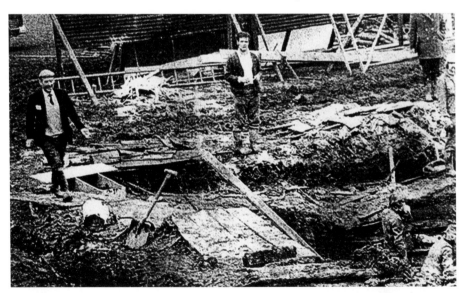

The mass exhumations begin. (Discover Liverpool Library)

the Home Office, ordering that the entire site be immediately enclosed with a 10-foot-high, solid and secure fence with a locked gate. The site manager was also instructed that this was to be regarded as a restricted area and that no members of the public should be allowed on site. However, the exhumations were ordered to continue.

By this time though, the press had got wind of the gruesome find, but they suddenly found themselves the subject of a D-Notice from the government. This specifically prevented them from publishing any stories or pictures about the 'Old Swan Mass Grave'.

Soon after the instruction to erect the fence another edict came from the Home Office, this time ordering the immediate cremation of the coffins and their contents, followed by the interment of the remains in an unmarked site in nearby Anfield Cemetery. These instructions were carried out with great haste. Work on the new St Oswald's Schools was halted for eighteen months whilst a complete pall of silence descended over the site and the story. Nevertheless, speculation was rife (although not in public) about the origins of the bodies; the circumstances of the peoples' deaths; and the reason for such a mass, unmarked burial pit.

As none of the coffins bore nameplates, one belief was that this indicated that the burials dated from before 1840. This was because it was only after that date that registration of burials became compulsory and all coffins had to be identified. But this still left many questions unanswered.

Could these unfortunate people have been victims of the grisly Black Death, or bubonic plague, which had ravaged Britain, and especially Liverpool, throughout the Middle Ages, and especially throughout the seventeenth century? This was unlikely,

The site of the mass graves today. (Discover Liverpool Library)

as plague victims' bodies were simply dumped, without coffins, in mass pits and covered with quicklime before being buried.

Alternatively, might they have been poor people from the Victorian slums of Liverpool, who had died in one of the many later plagues of the town, such as cholera, typhoid, or dysentery? If so, why are there no records of such an exceptional burial in the City Records Office?

Why were the Home Office so intent on hushing up the story and so determined to destroy the evidence so quickly, especially before any post-mortems or samples could be taken for analysis and possible identification? The fact that all the coffins had been buried in such a methodical and orderly manner showed that this had been a highly organised process. This implies the likely involvement of military personnel in the burials.

Speculation continued, but soon life moved on. The schools were eventually built, and they are still open and happily serving the local community and parish to this day.

The story gained a new lease of life in 1995, when some local historians contacted the Home Office for information about the burial pit. Even after over

Irish Potato Famine victims in the mid-nineteenth century. (Discover Liverpool Library)

twenty years, a spokesperson for the government denied all knowledge of the case and said that they had no records of the alleged 'mass grave'. They said that it was likely that this was all an invention of opportunist sensationalists or over-imaginative local people. But as there had been so many people present and involved at the time this position taken by the Home Office had no validity.

To date, the government still denies the existence of any records. Naturally, no detailed press reports exist, and I have only been able to trace a couple of very poor photographs of the gravesite.

Perhaps a more likely explanation is that these people had been Irish Potato Famine migrants to Liverpool, in the mid-1840s, who had been so weakened by starvation that they easily fell victim to Victorian epidemic disease. Being only 'peasants', perhaps the Victorian authorities of the time simply buried them out of the way, and saw no need to record either their identities or the fact of their interment, or to nameplate the coffins.

Perhaps the reason for the subsequent official denials and obstruction is due to the politically sensitive nature of the times in which the bodies were discovered. During the 1970s, tensions between Britain and Irish Nationalists were at such a bloody peak that bombs and other terrorist atrocities seemed to be happening virtually every week, both in Northern Ireland and on the British mainland. For the government of the day to admit that Irish people had been treated with such disrespect, even though a hundred years previously, would have provoked outrage amongst the Irish community with potentially violent consequences – if indeed this was the truth behind the mass grave of course. But this is simply my own speculation for, as I have said, no official records exist.

Nevertheless, whatever the explanation may be for these anonymous burials, it is only right that we spare a kindly and respectful thought for those 3,561 unknown people in their unmarked graves, and in their equally uncertain final resting place.

LIVERPOOL'S GRIM GAOLS AND 'THE LONG DROP'

This book has been a collection of stories of crimes, of varying severity, and of the criminals who perpetrated them. In the first entries I talked about the early punishments that were meted out to those found guilty of such offences; penalties that required corporal punishment or a period of incarceration; or the ultimate penalty, that of death by execution. Also in the first entry I described the function and conditions of the ancient Tower of Liverpool and how it ultimately became the Town Gaol.

Now, to close this book, I will describe how those punishments and places of imprisonment changed over the centuries. To do so, I will begin by returning to the Tower of Liverpool, which, by the mid-eighteenth century, had become severely dilapidated and the conditions for its prisoners were now dire indeed.

In 1774, however, the highly respected prison reformer John Howard (1726–90) paid a visit to the town. He examined each of Liverpool's gaols, bridewells, and lock-ups as part of his national inspection tour of Britain's prisons.

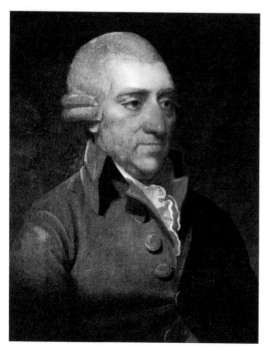

John Howard, the great prison reformer. (Liverpool Athenaeum Library)

He was particularly appalled at the overcrowding and filth in the primitive old Tower, the cells of which were awash with urine, vomit, and excrement. Howard insisted that this be closed as a gaol as soon as possible and replaced by a more civilised and wholesome establishment. He also used Liverpool as a prime example of the desperate, national need for drastic changes to be made in the whole attitude to the imprisonment and general treatment of criminals. The Town Corporation were so embarrassed by his very public exposure of this scandal that they invested in the first 'modern' prison to be built in Liverpool. This was also the first purpose-built, 'locally administered penitentiary' in Britain. Even so, construction work did not begin until 1785, but Howard later returned to Liverpool to check on progress and was impressed by what he found.

The new gaol had been erected on a street that the Corporation named in honour of the reformer, 'Great Howard Street'. The building was named the 'Liverpool Borough Jail' and had been designed by London-born prison architect William Blackburne (1750–90), but with contributions by Howard himself. The structure comprised six blocks of single-occupancy cells, on three levels, which fanned out in a semicircle from a central administration unit. This meant that all levels of cells, their corridors, and their prisoners could be observed by warders from a single, central observation point. This meant that the new gaol was revolutionary because it pre-empted the government's Penitentiary Act of 1799. Amongst other provisions, this Act specified that gaols should be built with one cell per prisoner.

Liverpool's new Borough Gaol. (Liverpool Athenaeum Library)

It was also in advance of the later official 'panopticon' prisons, which consisted of separate, multi-level wings of cells radiating out from a central hub, rather like spokes on a wheel. Whilst this design concept is generally attributed to another great English thinker and reformer, Jeremy Bentham (1748–1832), it seems that Blackburne and Howard were ahead of their time. It was not until 1791 that Bentham published his idea, which then became the standard design for British prisons for over fifty years. Many of these prisons are still in use today including, as we shall see, in Liverpool.

Although as yet unfinished, by the turn of the eighteenth century and during the first twenty years of its existence, around 4,000 prisoners of war spent varying periods of time in the new Borough Gaol. These were French soldiers and sailors captured during the Napoleonic Wars (1803–15) and, as a result, the building became known in the town as 'The French Prison'.

Sadly, and despite being housed in a new building, conditions here were not much better than those in the Tower. The gaol could be stifling in summer and freezing in winter. Food was limited in quantity and very poor in quality. In fact,

The Borough Gaol shown on an old map of the town. (Liverpool Athenaeum Library)

and once again, many captives were forced to survive by catching and eating rats, mice, and larger insects.

They also had to earn money to buy food from their jailers, by constructing and selling toys, trinkets, and model ships and animals. These pieces of 'scrimshaw' were often intricately carved from bits of bone and scraps of wood, and were then sold to visiting members of the public. Some of these items survive in the Museum of Liverpool, and they are remarkably detailed and quite beautiful.

Townspeople were allowed to enter the prison for their own entertainment, rather like going to a zoo, providing they paid a few pence as a bribe to the jailers. The prisoners also put on concerts and performed plays for these 'tourists', receiving payment in money, or in food and smaller items of clothing.

Liverpool's local criminals, as well as incarcerated debtors, only began to be moved from the cells and dungeons of the Tower and into the Borough Gaol from 1811. This was when the Frenchmen began to be released and repatriated, but even so, thirty-six years had passed since Howard had condemned the medieval building! The grisly old Tower of Liverpool was eventually demolished in 1819, and modern 'Tower Buildings' now stands on the site.

As the population of Liverpool rapidly expanded throughout the nineteenth century, so did incidents of both petty and violent crime. Larger and more secure prisons were now required, because the old Borough Gaol could only accommodate a maximum of around 400 inmates at any one time. So, in 1819, a new prison was built at Kirkdale, just to the north of the town, on the road to Bootle. This stood near modern Kirkdale railway station and it was one of the largest and most modern prisons in England at that time.

Despite having an official capacity of around 600 prisoners, Kirkdale Prison also became overcrowded. It was soon unable to meet the rising demand for cells. As a result, in 1855, another and much larger prison was built at Walton, also to the north of the town centre. This prison was deliberately constructed to be a grim and forbidding complex. Its main entrance (which is now largely obscured by a much more secure, high surrounding wall) was an imposing castle-like block.

The prison was designed by the then Town Architect, John Weightman (1798–1883), using Bentham's panopticon principle. It had single cells to accommodate an average of between 800 and 1,000 prisoners in eight, five-storey wings. Originally, these were for both male and female prisoners but housed in separate blocks. Punctuating the tall walls of the wings, at each of their levels, rows of small, glazed, but barred windows still let daylight into the cells within.

By 1865, the old Borough Gaol on Great Howard Street had been demolished. Kirkdale itself closed in 1897, and its prisoners were transferred to nearby Walton. This was done simply by marching them through the streets. Soon afterwards Kirkdale Prison was also demolished and its site is now a park and recreation ground.

What became known locally as 'Walton Jail' is now named 'Her Majesty's Prison Liverpool', and is for male prisoners only. An entire wing was bombed

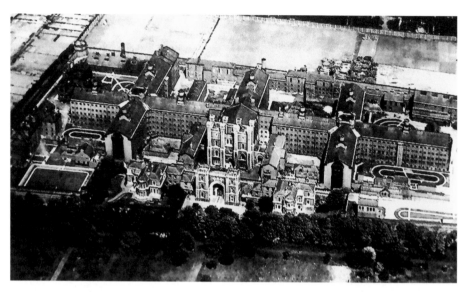

Walton Prison.

during the Second World War and, although this was never rebuilt, the prison can accept up to 1,500 inmates. However, this is sometimes with three men in cells originally designed for one person. The building is often filled to capacity and is currently the largest prison for men in Western Europe. It is also (at the time of publication of this book) one of the worst prisons in Europe by almost every possible standard of measurement.

But, and as we have seen, prison terms were not the only punishments meted out to criminals; for the most serious crimes execution was the most likely sentence. Over the centuries many people had been publicly put to death at the old Tower of Liverpool, as well as at other locations around the town. Before the start of the nineteenth century death was often carried out by beheading, as well as by more unpleasant methods. These included pressing under stones and weights; hanging, drawing, and quartering; burning alive at the stake; and by the traditional method of hanging from a beam or scaffold, which as we have seen caused death by slow strangulation.

Executions were carried out at both Kirkdale and Walton prisons, and at Kirkdale these had also been held in public. Condemned men and women were hanged on a scaffold erected outside the prison walls in front of often vast crowds. This was supposed to act as a deterrent but, in fact, this simply provided a thrilling entertainment and a chance for a day out and a picnic, for people for whom life was cheap anyway. Special 'execution excursions' were organised, and horse-drawn carts and coaches full of people travelled the roads to the prison, whilst special ferryboat trips carried hundreds of river-borne spectators to Kirkdale. These vessels anchored close to the Mersey shore, opposite Kirkdale Prison, providing a grandstand view for the happy passengers.

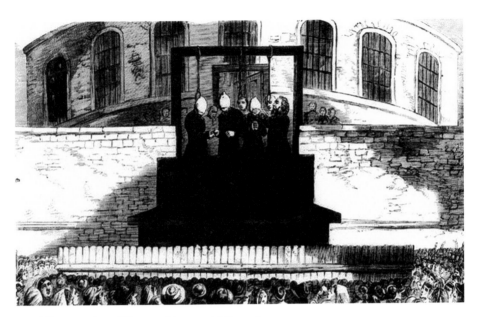

A public execution. (Discover Liverpool Library)

Men, women, and children would excitedly chatter and gossip until the prisoner (and there was often more than one) was brought out and his head placed in the gallows noose. The trapdoor upon which the condemned prisoner stood was usually held closed by props beneath it. The executioner then had to go below and knock these out of the way to release the drop. When the prisoner fell and the strangling began great cheers of delight would usually go up from those watching. This was unless the prisoner was popular with the people, when just as loud cries of distress and anger would result.

Sometimes friends of the victim would rush forward to pull down on their legs, to try to hasten their deaths. This is where the phrase 'pulling my leg' comes from.

The last person to be hanged in public in Britain was Michael Barrett, who was executed on 26 May 1868. A militant Irish Republican, Barrett had placed a bomb in a wheelbarrow in a busy street in Clerkenwell, London. When this exploded it killed twelve innocent bystanders. There were no cries of distress or anger from the crowds when he was hanged outside the walls of Newgate Prison.

It was in 1868 that the law was changed and executions no longer took place as a public spectacle. By this time though, hanging had become the only official method of execution and the process was generally becoming much quicker and more efficient. This was because hanging now utilised a drop through a quick-release trapdoor that opened onto a deep pit. As the condemned person fell his descent was sharply halted by the rope around his neck that was fixed to the gallows bar above. Also, the noose was now positioned in such a way that the body weight of the convict would then cause his neck to be snapped sharply. This was known as 'the long drop'

and it resulted in an almost instantaneous and more humane death – that was providing the executioner was experienced and efficient of course; there had been some unexpected decapitations! At one early public hanging at Kirkdale, the executioner was so incompetent that the head of the condemned man was almost pulled from his shoulders. According to witnesses there was a horrid squelching sound and blood squirted everywhere.

After 1868, and in common with all other large British prisons of the time, Kirkdale and Walton now both had 'execution sheds' inside which the hangings were carried out. These were located well within the prison walls and away from the public. However, both gaols shared the same, fully portable scaffold and gallows, which was transported between the prisons as required. However, in 1885, the trapdoor failed to open on the gallows being used in Exeter Prison. This was a standard design in use across Britain, so now the Home Office commissioned Lieutenant Colonel Alton Beamish to design a more efficient, standard model of gallows and drop for permanent installation in all British prisons: no more shared, portable contraptions.

This updated design consisted of two uprights, spanned by a length of oak beam measuring 8 inches square. This was long enough to execute three prisoners side by side using a double trapdoor that was 12 feet long by 4 feet wide. An efficient lever and bolt mechanism now opened the hinged doors of the trap in one very quick and smooth action.

The first person to die in Britain using the new design of gallows was the robber and murderer Matthew William Chadwick, and this was at Kirkdale on 15 April 1890. In fact, both of Liverpool's Victorian prisons were the scene of many state-sanctioned executions from 1887 to 1964, when executions ended in Britain. In Walton Prison alone sixty-two people were executed during this period.

The execution chamber inside Kirkdale Prison. (Liverpool Athenaeum Library)

Ruth Ellis, the last woman to be hanged in Britain.

In 1892, a new execution chamber with an adjoining condemned cell had been constructed at Walton. This was made by connecting the last two cells on 'I' Wing and by converting the cell immediately below into the hanging pit. Even though, after 1964, the execution area was converted back into ordinary cells again, part of the gallows beam can still be seen as a section of the internal wall. It is also said that the ghosts of some of the unfortunates hanged at Walton still haunt this part of the prison.

The last woman to be executed in Britain was the murderess Ruth Ellis. Found guilty of shooting her violent and abusive boyfriend, she was hanged at Holloway Prison in London on 13 July 1955, at 09.01 a.m. Aged twenty-nine, she died at the hands of the man who was then Britain's principal executioner, Albert Pierrepoint (1905–92). By this time, the process of judicial killing had reached a peak of efficiency, particularly because of the skills of professionals like Pierrepoint. This meant that from the time Ellis walked into the execution chamber to the moment of her death only ten seconds passed.

Pierrepoint had succeeded his uncles, Henry (1878–1922) and Thomas (1870–1954) Pierrepoint, to become the country's most senior and experienced hangman. He brought great competence, skill, and what compassion he could to his work but, after executing Ellis, two weeks later Pierrepoint carried out his last hanging. This was of Norman Green from Wigan who had brutally stabbed to death two young boys, and it was carried out at Walton. Albert Pierrepoint then resigned as Britain's longest-serving and most prolific executioner, for reasons that have never been satisfactorily explained.

In his twenty-five-year career Pierrepoint is estimated to have hanged between 450 and 600 men and women. These included around 200 Nazi war criminals at Nuremberg, at the end of the Second World War. He and his wife retired to the seaside town of Southport, just north of Liverpool, where they ran a very popular pub. Pierrepoint died peacefully at the age of eighty-seven.

The last executions to take place in Britain were of two male accomplices in a violent robbery and brutal murder, and their simultaneous hangings took place on Thursday 13 August 1964. The names of the condemned men were Peter Anthony Allen, who was twenty-one years old, and Gwynne Owen Evans (aka John Robson Walby, or Welaby), who was twenty-four years old. On the day before his execution Allen was being visited by his wife. He suddenly threw himself violently against the glass that separated them and he slightly cut his wrists.

Albert Pierrepoint, Britain's longest-serving executioner.

Nevertheless, the following morning his execution went ahead. As he entered the execution chamber he is said to have called out 'Jesus!' when he saw the noose hanging from the gallows beam.

By this time multiple executions had long since ended and so the two young men were hanged in separate prisons: Evans died at Strangeways Prison in Manchester and Allen at Walton Prison.

To ensure that no prison could claim the 'honour' of carrying out Britain's last execution, the Home Office decreed that the gallows trapdoors in both execution chambers should fall at precisely the same time. This was to be at 08.00 a.m., and the clocks at Strangeways and at Walton were synchronised accordingly. However, senior prison officers at Walton Prison told me that they were determined to be the last place of execution in the country, so they moved their clocks back five minutes!

Whether this is true or not, on that August day in 1964, capital punishment and 'the long drop' ended in Britain. The Home Office decided that those condemned prisoners still awaiting execution in the country's jails should have their death sentences commuted. Even so, hanging remained a statutory penalty in British law for certain other offences, including piracy and treason, but was never imposed. Judicial execution in the UK was finally formally and completely abolished in 1998.

Evans and Allen, the last people to be hanged in Britain. (Discover Liverpool Library)

SELECT BIBLIOGRAPHY

Bailey, F. A., and Millington, R., *Story of Liverpool* (Liverpool: Corporation of Liverpool, 1957)

Barthorp, Michael, *The Jacobite Rebellions* (Bloomsbury Publishing PLC, 2000)

Begg, Paul, 'Jack the Ripper: The Facts.' (Barnes and Noble Books, 2005)

Belchem, J. (Ed)., *Liverpool 800* (Liverpool, 2006)

Brownbill, J. and Farrer, W., *A History of the County of Lancashire* (eds.) (Victoria County)

Burke, Vincent, *Merseyside Murders and Trials* (History Press, 2008)

Chandler, George, *Liverpool* (London: B T Batsford Ltd, 1957)

Charters, David, *Great Liverpudlians* (Lancaster: Palatine Books, 2010)

Chitty, Gill, The *Changing Face of Liverpool, 1207-1727.* (Liverpool: Merseyside Archaeological Society, 1981)

Cullen, Tom, *Crippen: The Mild Murderer* (Penguin Books. 1998)

Eddleston, John J., *The Encyclopaedia of Executions* (John Blake Publishing Limited)

Hand, Charles, *Olde Liverpoole and Its Charter* (Liverpool: Hand & Co., 1907)

Hanrahan, David C., *The Assassination of the Prime Minister* (History Press, 2008)

Hinchliffe, J., *Maritime Mercantile City* (Liverpool: Liverpool City Council, 2003)

Hodgson, H., *Liverpool* (RHO, 1788)

Howell-Williams, P., *Liverpolitania* (Liverpool: Merseyside Civic Society, 1971)

Huson, Richard (Ed.), *Sixty Famous Trials* (a *Daily Express* publication)

Jarvis, R. C., *The Town of Liverpool in the '45* (Liverpool, 1956)

Lane, T., *City of the Sea* (Liverpool: Liverpool University Press, 1997)

Macilwee, Michael, *The Liverpool Underworld: Crime in the City 1750-1900* (Liverpool University Press, 2011)

Macilwee, Michael, *Liverpool Gangs* (Milo Books, 2006)

McIntyre-Brown, Arabella, *Liverpool: The First 1,000 Years* (Garlic Press, 2002)

Muir, R., *A History of Liverpool* (London: Williams & Norgate, 1907)

Neild, James, *The State of the Prisons of England, Scotland and Wales* (London, 1812)

Parry, David, *Merseyside Murders* (Palatine Books, 1993)

Pierrepoint, Albert, *Executioner: Pierrepoint* (London: Coronet, 1977)

Pye, K., *Liverpool: The Rise, Fall, and Renaissance of a World Class City* (Amberley, 2014)

Pye, K., *Merseyside Tales* and *More Merseyside Tales* (History Press, 2015)

Pye, K., *The Bloody History of Liverpool* (History Press, 2011)

Sleman, Thomas, *Murder on Merseyside* (Robert Hale Limited, London)

Various Contributors, *A Guide to Liverpool 1902* (London: Ward, Lock & Co., 1902)

Various Contributors, *The Stranger in Liverpool* (Liverpool, 1902)

Warren, C. E. T., *Thetis – The Admiralty Regrets: The Disaster in Liverpool Bay* (Avid Publications, 1997)

Whale, Derek, *Lost Villages of Liverpool: All Parts* (Prescot: T. Stephenson & Sons, 1985)

Whittington-Egan, Richard, *Tales of Liverpool* (The Bluecoat Press)

Whitworth, Rodney, *Merseyside At War* (Liverpool: Scouse Press, 2016)

Other sources include:

London Pall Mall Gazette (1898)
Welsh Evening Express (1898)

ACKNOWLEDGEMENTS

I certainly hope that you have enjoyed this selection of some of the more serious crimes and their criminals perpetrated in Liverpool over the last 800 years or so. It was a fascinating pleasure to research and write this book, the latest in my series describing so many aspects of the lives and histories of the large and diverse community of Liverpool City region.

To be a native Liverpudlian is a continuing source of personal pride and joy. Investigating the more significant if unusual elements of our social and cultural heritage has only reinforced this.

There are a number of individuals and organisations who assisted my research, and who supported me during the writing of the book. In particular I would like to thank my many friends for their knowledge and encouragement, but especially my children, Ben, Sammy, and Danny, and my wife, Jackie.

For the sources for my stories I would also like to acknowledge, as always, the professionalism and support of my fellow members of the Liverpool, Wavertree, Woolton, West Derby, Garston, and Gateacre historical societies; the librarians of The Athenaeum; and the staff of the Liverpool City Records Office.

ABOUT THE AUTHOR

Born and bred in Liverpool, Ken Pye recently retired as the Managing Director of 'The Knowledge Group'. In a varied career spanning over fifty years, Ken has experience in each professional sector. This includes working as a Residential Child Care Officer for youngsters with profound special needs, as a Youth and Community Leader, as the Community Development Worker for Toxteth, as the Northwest Regional Officer for Barnardo's, as the National Partnership Director for the Business Environment Association, and as Senior Programme Director with Common Purpose. He also undertook a special one-year contract for Liverpool Hope University as Executive Director of Continuing Professional Development, before setting up 'The Knowledge Group' in 2009.

Ken is a Proprietor of The Athenaeum, a Fellow of Liverpool Hope University, and a Fellow of the Royal Society of Arts.

Ken also continues as the Managing Director of his own local history company, 'Discover Liverpool', which he established in 2005. As such, he is a recognised expert on the past, present, and future potential of his home city and is a frequent contributor to journals, magazines, and newspapers. He is also a popular after-dinner speaker and a guest lecturer to a wide range of groups and organisations, and is a regular broadcaster for both radio and television.

Well known across Merseyside and the North West, Ken is the author of many books on the history of his home city and its city region, and is a widely recognised expert in his field. Ken's other published works are:

Discover Liverpool (now in its third edition)
A Brighter Hope – about the founding and history of Liverpool Hope University
Merseyside Tales and *More Merseyside Tales*
Liverpool: The Rise, Fall and Renaissance of a World Class City – his complete history of the city, also in its third edition
Liverpool Pubs;
The Bloody History of Liverpool (now in its third edition)
Liverpool At Work
The A to Z of Little-Known Liverpool
Liverpool's Military Heritage
Two Triangles: Liverpool, Slavery, and The Church

Ken was also a significant contributor to Trinity Mirror's celebration of Liverpool and its people – *Scousers,* and the special advisor on *Sung and Unsung* – a collection of portrait photographs and biographies of the 'Great and the Good' of Liverpool.

Having also completed two books privately commissioned by the 19th Earl of Derby, Ken has also issued his set of four audio CDs on which he reads his stories of the *Curious Characters and Tales of Merseyside.* Also available is Ken's brand-new, fully revised third edition of his eight-volume filmed DVD documentary series *Discover Liverpool.*

On a personal basis and if pressed (better still, if taken out to dinner), Ken will regale you with tales from his own fascinating life, including his experiences as a child entrepreneur, as a bingo caller, as a puppeteer, as the lead singer of a 1960s pop group, as an artists' and photographers' model, as a mortuary attendant, and during the Toxteth Riots.

Ken is married to Jackie, and they have three grown-up children: Ben, Samantha, and Danny.

Visit Ken's website at www.discover-liverpool.com.

Ken Pye with his family. (Discover Liverpool Library)